A Gallery without Walls

Selling Art in Alternative Venues

BY MARGARET DANIELAK

A Gallery without Walls: Selling Art in Alternative Venues

Copyright 2005 by Margaret Danielak

Cover and layout by Laura Davis

Sketches by Robert G Stevens

Published by ArtNetwork, PO Box 1360, Nevada City, CA 95959-1360
800.383.0677 530.470.0862 530.470.0256 Fax
www.artmarketing.com <info@artmarketing.com>

ArtNetwork was created in 1986 with the idea of teaching fine artists how to earn a living from their creations. In addition to publishing art marketing books and newsletters, ArtNetwork also has a myriad of mailing lists—which we use to market our products—available for rent. See the back of this book for details.

The author, Margaret Danielak, may be contacted at 626.683.9922
www.danielakart.com <thinkcap@earthlink.net>

Danielak, Margaret.

 A gallery without walls : selling art in alternative venues / by
 Margaret Danielak. -- 1st ed. -- Nevada City, CA : ArtNetwork, 2005.

 p. ; cm.

 Includes index.
 ISBN: 0-940899-46-9
 ISBN-13: 978-0-940899-46-9

 1. Art--Marketing. 2. Selling. 3. Art--Economic aspects.
 4. Marketing channels. I. Title. II. Selling art in alternative venues.

N8600 .D36 2005

658.8/7--dc22 0510

DISCLAIMER: The publisher and author bear no responsibility or liability that might occur from using the information, heeding the advice or participating in the activities described herein.

Printed and bound in the United States of America

Foreword

About six years ago, I was teaching a marketing workshop in Santa Fe, New Mexico. The room was filled with artists. I was getting lots of interesting questions, from one participant in particular. She seemed to be absorbing everything I was presenting.

During the break, the woman came up to me and introduced herself as Margaret Danielak. When we had a chance to talk, Margaret explained how she wanted to work with artists, but not in the traditional way. She wanted to help them get exhibits and sell their work without commercial galleries being involved. She told me several stories about working with her father—a painter—and some of the successes she was having selling his work. She noted that she was looking for other artists to work with and that she would keep me updated.

About a year later, Margaret contacted me again. She was having a variety of receptions and shows in alternative venues for her father's artwork as well as several other artists. Impressively, she was selling their work directly to art buyers. She had put into place a system for selling art without "gallery walls."

Since that time, we have kept in touch. I have seen Margaret go from a woman with a dream of working with artists in a non-traditional way to a successful agent for artists.

Margaret is a good example of someone who had an interesting idea, turned it into a realistic business plan, and has used it to succeed at promoting and selling her artists' work. Margaret is an inspiration to us all.

So ask questions. Explore the terrain. Use your imagination. Try a new approach. Margaret Danielak has done all of this. She has created a successful business as well as written an extremely helpful book that every artist should read. It offers great marketing ideas, provides tips on acting as your own salesperson, and gives a clear picture of how artists can work successfully outside the traditional gallery system.

<div align="right">

Geoffrey Gorman
Founder, Artist Career Training

</div>

About the author

Margaret Danielak is the daughter of artists and the owner of DanielakArt - A Gallery Without Walls. She is a graduate of the University of California at Berkeley, was a Producer Fellow at The American Film Institute, and is a published author on the subject of art marketing.

DanielakArt has exhibited the work of its artists at California School for Culinary Arts in Pasadena, select local restaurants, high-end wine shops, bookstores, a major medical center, the Fine Artists Factory in Pasadena, California, Paramount Pictures in Hollywood, and Lankershim Art Gallery in North Hollywood, amongst other locations. She is a member of The Junior League of Pasadena and The Pasadena Arts Council. DanielakArt - A Gallery Without Walls is an Industry Partner Member of the American Society of Interior Designers (ASID).

Margaret Danielak has sold art in her home and her artists' homes with great success, particularly during Art Teas, which she holds regularly.

About the illustrator

Robert G "Bob" Stevens (1926 - 2004) began his artistic career sketching during World War II while stationed in the South Pacific. A San Francisco Bay Area native, he returned home after the war to attend the California College of Arts and Crafts (CCAC) in Oakland, where he studied under noted California-scene painter George Post. After graduating in 1950, Stevens applied his drawing skills as a scientific illustrator for the Lawrence Laboratories, working first in Livermore, California and then for many years in Berkeley, California. He became Principal Scientific Illustrator for the Lab, working closely with many Nobel Prize-winning scientists on projects that have only recently been declassified.

Stevens fell in love with the Southwest during a vacation to New Mexico in 1971. In 1984 he moved with his wife, Wilkie, to Santa Fe to paint full time. He was co-founder of the OLGA Group of Artists, exhibiting and selling his work both on his own and through galleries in Santa Fe. His daughter, author Margaret Danielak, formed DanielakArt - A Gallery Without Walls in 2000, primarily to represent her father's work.

The illustrations for this book were found in Stevens' many sketchbooks (which he once threatened to throw away but his wife saved). They were selected by the author.

TABLE OF CONTENTS

Chapter 4 Taking Care of Business

Chapter 5 Alternative Venues

Chapter 6 Themed Events

Chapter 7 Successful Events

Chapter 8 Hosting a Reception

Chapter 9 *Selling the Art*

Chapter 10 *Following Up with Contacts*

Chapter 11 *Sales Strategies for Mature Artists*

Chapter 12 *Marketing Attitudes*

Appendix

Introduction

In the past, most artists needed gallery representation to be successful. Gallery owners guided your career and "got behind you." They promoted your name, exhibited and sold your work, gave you one-man shows, and created glossy brochures that they mailed out to their clients. They helped secure media coverage for your exhibitions and used their contacts to generate excitement for your work. For many artists, getting into a good gallery was like finding the Holy Grail—a quasi-religious experience.

Technology—specifically the Internet—has changed the art business tremendously, especially for individual artists, enabling them to reach directly, and rather, easily, art-buyers worldwide. Desktop publishing has further empowered artists, making it possible for them to create their own professional-looking promotional materials.

Artists are finally realizing that they need to become more savvy as businesspeople and pay attention to the marketing of their work in a whole new way. They have been forced to learn how to promote their work and not to rely upon others to do it for them.

Most importantly, economic pressures have forced many good galleries to close, creating a serious lack of exhibition space for the ever-increasing number of artists who wish to sell their work.

Today, successful artists are not relying solely upon galleries to sell their work and promote their careers. They are learning to take control by reaching out directly to the art-buying public, exhibiting art where previously undiscovered collectors live, work and play.

How I got started

Growing up in the San Francisco Bay area, I accompanied my artistic parents to numerous outdoor art shows, local gallery openings and museums. Many of my parents' friends were artists, some well-known. I often overheard their conversations about their great joy in creating art and their intense frustration in trying to sell it. I also learned about the history of art and how professionals display and sell their artwork.

After graduating from UC Berkeley with a degree in history, I assisted the Station Manager of San Francisco's Public Television Station (KQED), where I learned exactly how difficult it is to create quality visuals (educational programming) on a very limited budget. In my late 20s, I became enamored with film and was accepted into film school, where I learned how important it is to have professional contacts. After film school, I secured a position apprenticing to a Hollywood producer, then became a production coordinator, where I learned production management.

After six years in the film industry, I accepted a position working as the assistant to the senior partner of a law firm, a man who loved what he did and was brilliant at

marketing the unique services of his firm. In some respects, I went from the frying pan into the fire. From a marketing point of view, it was a smart move, because I learned some important lessons, amongst them that cultivating new clients takes time. Sometimes, it requires as many as nine contacts before a person becomes a client.

Not surprisingly, my adventure selling art began at a law firm. I showed my father's portfolio to several co-workers and immediately sold, on the basis of a note card featuring one of his images, a painting to a woman who had never before purchased original art.

My adventure then continued with a big "Holiday Art Party"—a ripping affair where everyone was happily over-served, and nothing, to my great distress, sold. At the time, I did not understand why, but I do now. Many of the attendees were seeing my father's paintings for the first time, and they were not focusing on the art. Additionally, my mental goal that evening was to throw a great party for my friends and neighbors. My goal was not to make sales. So I didn't.

Keeping in mind my training at the law firm, right after Christmas, I started calling everyone to wish them a Happy New Year and, if they had attended the event, to thank them for coming. If they were unable to attend, I told them all about it and emphasized how much they were missed.

One of the people I contacted was my lovely neighbor, who, on New Year's Day during the Rose Bowl Parade, called me back to ask if she could see the work again and bring over her friend, who happened to be the vice president of a local bank.

As I recall, it was a very clear "Chamber of Commerce day" in my hometown of Pasadena, California. The floats were floating and the crowds roaring as the Rose Parade progressed down Colorado Boulevard, not six blocks from my house. It was a day when a million people were out, and all of the galleries in Pasadena were closed. It was also the glorious day when I sold four of my father's paintings. And, after following up with other people, quickly sold five more.

From this experience, I realized that I could represent artists and sell their work. I launched my first "Gallery Without Walls."

The steps I follow and issues I consider as outlined in this book are, therefore, based on my experience representing artists by selling their work in alternative venues and in unusual, cost-effective ways. These steps are not difficult to follow. Filled with helpful tips, amusing stories, and step-by-step instructions, this book will, hopefully, inspire you to think differently about the promotion of your art, representing artists or selling art.

How this book came to be

This book is an outgrowth of several articles I wrote about creating successful "Art Tea" events and promoting the work of mature artists. It also documents my experience in selling artwork in alternative venues over the past five years.

What this book is about

This book is about selling art in alternative venues and in innovative, cost-effective ways. For artists, art reps, and dealers (and even gallery owners!) who wish to have greater presence in the marketplace, this book will outline for you how it can be done. If you wish to become an art rep, this book will show you how to get started.

This book is also a guide that will lead you to a greater understanding of how to select and then reserve the best space to exhibit your work. It will give you recommendations about how to evaluate your artwork and prepare it for sale, with additional ideas about how to create compelling promotional materials. It will also teach you how to promote your artwork on a limited budget. You will also learn about "Sacred Sales Spots."

Most importantly, this book will give you step-by-step instructions on how to produce a low-cost, successful, themed art event and then guide you to even greater sales with follow-up strategies.

What are artists to do?

Reaching out to the art public is one solution. Sometimes this means changing one's orientation. It means abandoning the notion that people only buy art in traditional ways—in galleries and at auctions.

As I have learned, art buyers are everywhere. They are your neighbors, your friends, your co-workers. They shop where you shop. They live where you live. They are people you've met at your association and club meetings and at parties.

Exhibiting in alternative locations should become an important part of your strategy. The reasoning is simple: If you are paying for walls as well as a hefty commission on sales, why not find a good alternate venue where you can host your own reception? Why not create your very own "gallery without walls?"

You will need to make each presentation, exhibition and event look professional. You will need to back up that exhibition with business cards and brochures. You will also need to learn how to create an effective portfolio to show to business owners, art collectors and other art world professionals. In other words, you will need to learn how to package and market your work in addition to producing it. This will require some effort, but you will have a great economic incentive to learn how to do it.

Over time you will learn how best to present your art, as well as which venues are the right fit for it. Your overall success will be determined by your attitude, determination and marketing savvy.

Acknowledgements

I would like to thank my editor, Constance Smith of ArtNetwork, who inspired me to share my stories about art marketing with others. I would also like to thank my husband, Paul A Danielak, Jr, who has supported me in more ways than I can mention. My mother, artist Wilkie Stevens, read several drafts of this book and gave me excellent recommendations for improving it, and so I thank her kindly. I would like to thank my friend and mentor, Dennis Jakob, who has always encouraged me in each of my artistic pursuits. Dennis inspired me to change my slogan to "A Gallery Without Walls."

A big thank-you to Murray Raphel, author and marketing expert, for his kindness and encouragement, and to arts consultant Patrick Ela, for his continued support and excellent advice.

I would like to thank Aletta de Wal of Artist Career Training for sharing her creativity, and Jackie Maria Mangum and Nancy Kristofferson for their friendship, good humor, and ongoing support of DanielakArt - A Gallery Without Walls.

I would also like to thank my sister, author Laura Peters, for encouraging me to keep writing, and Geoffrey Gorman for writing the foreword to the book. Thanks also to artist Carole Whitmore for sharing her excellent story about her art show experiences.

Mainly, I would like to thank my late father, the landscape painter and illustrator Robert G Stevens (1926-2004), and each of my artists, both past and present, for inspiring me to reach out in new directions in order to find happy homes for their artwork.

Chapter 1
Evaluating Your Art

Creating art you love
Creating art that sells
Self-evaluating your art
Your inventory
Gallery and dealer evaluation
Launching an artist's career
Pricing

Buckeye

Art is the most complex, vitalizing and civilizing of human actions.
Thus, it is of biological necessity. L Moholy-Nagy, *Vision in Motion*

CREATING ART YOU LOVE

Loving what you create is the most important thing you need to do to sell your artwork.

Several years ago, I attended a reception at a local gallery for a nationally-known and collected artist. Many of the artist's collectors were in attendance, as well as members of the art organization of which he is an active member.

During the reception, the artist gave a speech and thanked everyone for coming. He never looked up at his audience. While looking down at the ground, he spoke briefly about his new body of work.

In not so many words, this award-winning artist told us that he was reluctant to tackle this particular new subject matter; it didn't really inspire him. Creating this new body of work was "sort of challenging," he explained, as he continued to look at the ground. Right after giving the speech, the artist left the gallery floor to join his collectors who had congregated around an elaborately staged table with food and drink, which had been set up in a courtyard behind the gallery, far away from the art.

This major artist, who usually commands thousands of dollars for his work, sold exactly three pieces that night. He did not sell any more paintings during the entire run of his exhibition. Considering the gallery's status, the artist's collector base and the expensive marketing materials created for the exhibition, his lack of sales was surprising. Clearly the artist did not like his new body of work, and it killed his sales.

Being true to yourself and enthusiastic about what you are creating will permeate every aspect of your presentation. It will shine through to potential collectors and will affect all of your marketing efforts.

Artists who create work they truly love sometimes cannot sell it. If this is your situation, you will need to do some research to learn why the work is not moving. Ask yourself:

What captivates the public's interest? Look at the color and the size of work created by artists who are currently selling well. Perhaps what you love to do is something that will capture public interest if it is presented in a new way, or perhaps at a new location.

What is universally appealing? Traditionally, landscapes sell better than any other type of painting. Florals and pieces depicting animals also tend to sell very well. Recently, collectors are rediscovering the human figure, and there has been a jump in the sale of figurative pieces, both paintings and drawings.

What media are selling? Are the pieces original oils, watercolors, lithographs, or giclées? Art buyers are becoming aware of art quilts and other fabric art and are acquiring and displaying quilts as they would traditional paintings.

At what price are pieces selling? Perhaps your work is overpriced for your market. Consider licensing your work or creating a series of less expensive reproductions, such as giclées.

How is the art displayed? Is the work framed well? Do your lighting choices enhance the work? Is there something you could try that would improve the overall presentation of your work?

CREATING ART THAT SELLS

Put your signature high enough so that it will not be cut off when the work is framed or reproduced.

SELF-EVALUATING YOUR ART

Joining an artists' critique group, attending shows, visiting museums, and talking to your clients will help you evaluate your work as well as select which pieces are your best.

Many artists have difficulty evaluating their own creations. They love the colors in one piece and the subject matter of another. When they spend extra time on a creation, they believe it is a better work. Some pieces mean more to an artist than others. The artist will insist that the pieces are wonderful and will most certainly sell. They understand their work and forget that others might not.

Sometimes artists fall madly in love with their own creations and have no idea that a piece is not their best and should not be entered in a contest, shown to a gallery or representative, or even put on display for sale.

Exhibiting in outdoor shows, where you will receive feedback and comments from people who do not know you, can help you see the differences between your various pieces.

One way to approach selling your work is to divide it into categories or tiers. You will then find it easier to see the differences between particular pieces.

Tier One
Your Tier One group contains pieces that have the best composition and color (if paintings) and are captivating (if sculpture). If they are photographs, they have an unusual feel. When your friends and family see this work, they get really excited about it. For record-keeping purposes, photograph and frame these pieces. This group would be considered your best work.

Tier Two
Tier Two pieces also have good color and composition. If they are abstract pieces, they are intriguing and executed in a way that excites fans of abstract art. Tier Two pieces are ones you feel will show well and sell well. You may not think that they are your absolute-best pieces, but you like them. Your friends and family like them too.

Tier Three
Put Tier Three pieces away to think about. You may need to re-crop this work, add to it, or put a more captivating frame on it. There may be a way to make it into a better piece, employing some technique that you haven't yet discovered.

Do not show any piece that does not fit into any of these categories.

Having an adequate inventory of art to sell is critical. One of the biggest mistakes artists make is trying to market their work with insufficient inventory.

I was once invited to an artist's studio, where he showed me a total of 10 completed pieces. Art reps, dealers and gallery owners need to see your best work as well as a large inventory. They need to know that if they sell a few pieces, there will be more available.

Your Tier One and Tier Two pieces, already photographed, inventoried, framed (if necessary) and fixed with wire (or podium if sculpture), should be ready to be displayed with one day's notice.

YOUR INVENTORY

Artists should have at least three exhibitions ready (30-50 pieces) at any given time.

BEING PREPARED PAYS OFF

Five years ago, when I was just getting started repping artists, the local Chamber of Commerce contacted me about exhibiting at their annual Business Meet and Greet event. The event coordinator was wondering if I had art that could be put on display. Apparently she had contacted each of the local galleries and art schools, but none responded. I heard about the event and thought it would be a great opportunity to show some of my father's paintings of Pasadena. The next day, I brought his framed pieces to the Chamber's offices and was accepted for a free booth at the event, which was taking place two days later. I ended up being the only art provider at the event. A hundred people signed my guest book, and several business owners, including the manager of a high-end hotel, invited me to display and sell artwork at their location. People were thrilled to learn about DanielakArt - A Gallery Without Walls.

Preparing to exhibit

Try to create pieces in a series, where the pieces are exactly the same size, feature similar images, have a common theme, or, when displayed, create the feeling of a series. There is something intriguing about seeing three pieces hung together, or five pieces that are painted to complement one another, or, once displayed, create an overall image.

GALLERY AND DEALER EVALUATION

An artist who is obnoxious, puts words in one's mouth, is pompous, unkempt or who cannot stop talking long enough for anyone to get a word in edgewise is not someone reps, dealers or galleries care to represent, no matter how much we might like their art.

Gallery owners, reps and dealers have definite criteria for evaluating artists and their work. Below is a checklist of some things reps consider when evaluating artists who are seeking representation:

➤ Is the work professional looking?

➤ Does the artist have a clear, distinct style?

➤ Does the artist create new work continuously?

➤ Does the artist have adequate inventory?

➤ Is the work consistent in quality?

➤ Has the artist won major grants and awards?

➤ What are the her credentials?

➤ With whom did he study?

➤ Where has the artist shown?

➤ How amiable is the artist?

➤ Can the artist "hold up" at an opening?

➤ Does a gallery or other rep in the immediate geographic area currently represent the artist?

➤ Does the artist have a local following?

➤ Does the artist have a national following?

➤ Is her work reproduced in art publications? Which ones?

➤ Is the artist proactive in selling his work?

➤ Does the artist only sell originals, or does she also sell multiples?

➤ At what price does her work currently sell?

Most importantly, we have to believe we can sell the art.

The artists I represent need to be able to speak with enthusiasm about their artwork since they will be featured during at least one Art Tea event (see Chapter 5). I like to give my clients the opportunity to meet the artist. I want my clients to feel that they are supporting professional artists.

As Robert Regis Dvorák says in his book *Selling Art 101*, "If you are an artist who wants to sell your work, you need to have a body of work—a number of paintings, prints, sculpture pieces, whatever you do, at minimum 12 to 20 pieces—that look like they were done by the same person, are all about the same size, are all in the same medium, are all completed, and have a contextual theme. Don't even attempt to go to an art gallery in search of representation unless you have that."

Moving the work

Traditional galleries have to move work very fast to meet their overhead costs, so they will not keep artists whose work does not sell immediately. This may sound harsh. Before I ran an art business I thought it was outrageous for artists to be booted out of galleries after only three months (or sometimes less). Once I started getting the invoices for insurance, supplies, reception costs, entertaining and booth fees, I began to see why galleries with even more overhead than I have with my wall-less gallery cannot wait around for an artist's work to sell.

Last year, a talented artist submitted his very professional portfolio of silver sculpture to me. Each of his well-crafted pieces depicted a delightful-looking marine animal, and each piece was mounted on driftwood. The artist, who had a solid background in the arts, good inventory, and serious credentials, was reaching out to dealers in cities across the country, hoping for greater exposure of his work. His promotional materials—brochures, website, and business card—were nicely presented, and the photos of his work were compelling. The artist was both articulate and polite on the phone, and his correspondence was to the point. Even though I was very impressed with both him and his portfolio, I passed on representing him because his style of art was not suited to the collectors in my community. I thought his pieces would look great in homes in beach communities. I therefore recommended that he submit his work to galleries in Laguna Beach, Carmel and Monterey, California. I even thought of a few places in San Francisco where his work might sell. I gave him the names and numbers of several good galleries to contact in those cities. He seemed happy for the feedback and thanked me for not sending him away empty-handed.

Catch 22

In the past, I have attempted to launch artists who have had no previous exhibits or sales. Attempting to build an artist's reputation and client base from the get-go is a long process. Most galleries and reps, including myself, will not commit to an artist who has not begun to develop his career.

You need to sell your work to build a reputation and client base. To do that, you may need help making sales. To obtain sufficient help—gallery or agent representation—you need to prove that you have already sold your work. Here we have the classic Catch 22.

Many artists solicit help from family and friends to promote their work, expand contacts, create promotional materials and make sales. There are many successful husband-wife teams "making it" in the art world.

One of the great advantages of exhibiting in alternative venues is that if you decide you want to get into a gallery, or acquire a good rep or dealer, you will have a track record of exhibiting and selling your work. You also will have built a mailing list. Galleries, art reps and dealers like to sign artists who are actively selling and are "proven."

LAUNCHING AN ARTIST'S CAREER

A professional artist who is proactive in his career is preferable to one who is not.

21

PRICING

Pricing art is not only challenging: it is often quite frustrating.

If you are a professional artist with many awards and a long exhibition history, national name recognition, major collectors, noted commissions and numerous past sales, you can charge higher prices for your original work than an emerging artist or one just out of college.

SEVEN PRICING FACTORS

I suggest that artists price their work based upon the following seven factors:

The Competition

What price are other artists—exhibiting in the same geographical area, with a similar background, producing work of a similar style, in the same medium—commanding for their work? Note that I do not ask, "What is being charged for the work?" but rather, "At what price is the work *actually* selling?" How many pieces is the artist actually selling? Try to find out the answers to these questions and you will learn your price range.

The price of everything, including art, is determined by what people are willing to pay and what the overall market will bear—not by how much time it took to create the item or how much money was spent promoting it.

Sales History

At what price have your pieces of a certain size and style sold in the past?

Name Recognition

The more your name gets known, the more your work will be in demand. As it becomes more popular, your prices can rise.

Size

Are your paintings seven feet long or five inches square? Size matters when pricing art. Even though it may take longer to paint a small piece, one generally cannot command as much for a small piece as for a large piece.

Beauty

Is your art "traditionally beautiful?" Are specific pieces of yours especially striking? Auction houses use several factors for assessing the value of the pieces they sell. I highly encourage artists to visit auction websites to see exactly what the auctioneers consider when selecting a price range. Beauty, you will note, is one of the important factors. If some of your pieces are exceptionally beautiful, colorful or recognizable, you may be able to command higher prices.

The Economy

If the economy is soft, you might need to reexamine your prices. Since art is considered to be a non-essential luxury item, you will need to ask yourself, do you really want your pieces to sell? What is more important to you—the sale of your work or the art itself? How you feel about your art is very important. Some of the work you have produced, you may simply not want to part with for less than a certain price. If you can afford to wait it out, then, by all means, hold on to this work. You just may be able to sell it for more money next year, in a different location, when you are exhibiting the work to a different group of people.

Available Inventory

Some artists produce a very limited number of original pieces, so they price their work very high—so high that the originals are not often sold. Such artists might wish to explore licensing and publishing so that they can keep their originals and make money on reproductions.

RAISING PRICES

Sometimes artists will tell me that they are going to raise their prices because someone told them they were "under-priced." More often than not, the person advising the artist was not an artist, gallery owner, rep or collector. Furthermore, the person giving this sage advice was not someone who had purchased art from either the artist or his gallery or rep. It is very easy for someone to tell you that your work is under-priced if he is not an art collector and has not purchased art and does not know the market.

Consider raising your prices if at least one of the following occurs:

➤ You have won a prestigious, nationally-recognized grant or award.

➤ Your other pieces of a particular size and price have sold easily.

➤ A major collector has acquired your work or commissioned a piece.

➤ A major museum has acquired your work or is hosting an exhibition, perhaps retrospective, of your work.

➤ You have obtained critical press coverage.

➤ You have become famous (or infamous!) overnight.

RECOMMENDED READING

Art Licensing 101 by Michael Woodward

Chapter 2

Preparing to Exhibit

Creating presentation materials

Photographing your work

Potential venues

Investigating the space

Indoor venues

Outdoor venues

Working the streets

Traits of a successful outdoor artist

Show resources

Luck is what happens when preparation meets opportunity. Seneca

CREATING PRESENTATION MATERIALS

In addition to having an adequate inventory of artwork, you will need several types of promotional materials to get started:

➤ Business card

➤ Portfolio

➤ Brochure

BUSINESS CARD

Several artists have related to me that they lost out on sales because they didn't have a business card with them at a time when they really needed one. One friend told me he was painting *en plein air* one day in a remote location, and a prospective client approached him indicating he wanted to buy the very painting he was working on when it was completed. Neither he nor his prospective client had a pen, paper or business card on hand, so he lost out on the sale because they did not know how to contact each other.

If you are an artist, it is essential that you have a business card on your person at all times. A business card will make you appear more professional and enable prospective clients to reach you easily.

If you print a four-color example of your work on your card, people will be easily reminded of the style of work you create. The card will act like a mini-brochure. My business cards, which I print at home, feature not only my complete logo and contact information, but also a tiny reproduction of a watercolor painted by my late father.

Business cards that are oriented vertically are difficult to use in a Rolodex. For this reason, I highly recommend that you create a business card that is a standard size, and that your contact information and sample of your work are placed on the card horizontally—landscape style.

Make it a habit to keep business cards with you, whether going to the grocery store or walking your dog.

PORTFOLIO

A portfolio should reflect who you are, show what you do and explain why you do it. It should be clean, thoughtfully presented and well organized.

Years ago, portfolios were large and black and had handles on them. They looked like large briefcases. They were designed so painters could carry their original work around with them to show gallery owners. Some artists still think that they should use this format. Occasionally an artist will show up at a gallery or approach a dealer or rep with one of these portfolios tucked under his arm. I've seen gallery owners literally run away when they see an artist whom they do not know come into their gallery with one of these portfolios in hand.

Today, before looking at original work, art world professionals and collectors review a very different type of portfolio—one that is smaller, lightweight and versatile enough to be updated constantly. An inexpensive, flexible, plastic three-ring binder that easily holds materials works best. The binders have an open cover into which one can slip a compelling image.

Contents

The contents of your portfolio will change slightly based upon your audience. Your "master" portfolio should include:

➤ A striking image on the cover, preferably with your contact information on it

➤ Cover letter (if mailing out to a client or business)

➤ Business card (put in front pocket)

➤ Bio

➤ Artist statement

➤ A tear sheet or show card of your work

➤ Recent press releases (photocopies)

➤ Labeled photographs (8-10 total) of your work. Use a plastic sleeve. Orient all vertically on the page so the viewer doesn't have to turn the binder around each time she turns the page.

Don't forget your web site and email address on all of your literature.

Use plastic sheet protectors to keep photographs and other materials from slipping around and deteriorating. The plastic covers will also give you the flexibility to change information as needed.

Add your name and logo on the spine of the binder portfolio so it can be located easily when placed in a pile or put on a shelf.

➤ Labeled slides (8-16 total) of your work (if required).

➤ A self-addressed stamped envelope (SASE), giving the recipient the option of returning it to you

I keep this type of binder portfolio on hand for each of my artists, as well as three portfolios featuring the entire group that I represent available to show at all times. I also have numerous smaller portfolios out in the field at any given time, as well as other, more extensive portfolios at the locations where my artists are exhibiting, as a reference for prospective clients.

Use recycled/returned postcard invitations as cover art for your portfolio.

I also keep multiple empty, colorful, plastic folders on hand. These folders have pockets into which I put materials about each of my artists (brochures with bios, resumés, copies of press pieces, etc.). I then put new, different or tailored information into each of the folders for clients or press people as needed.

I usually put recycled and extra show cards (postcards) from our exhibitions on the covers of the folders. These folders are far less expensive and time-consuming to prepare than the formal binder portfolio and are often the best thing to submit to the press or a prospective client. I never expect to get a folder of this type returned.

BROCHURE

I love brochures. I have sold many pieces from the brochures I've created for my artists. I not only use them for initial sales but send them to clients after completion of a sale, introducing clients to other works created by the same artist.

If you sell your work at outdoor art shows and other alternative venues, having a brochure will increase your ability to advertise your artwork and make sales. It is an inexpensive "take-away" item for your prospective clients, and people love to pick them up (the touch factor).

I use two different types of brochures: a tri-fold vertical brochure and a one-page brochure featuring several images on the front with the artist's bio on the back.

A brochure featuring your artwork is a great item to have on hand. The general public understands brochures, whereas they might not understand your master portfolio with bio, resumé, artist statement, etc.

A good brochure should be inexpensive to create and very portable.

PHOTOGRAPHING YOUR WORK

I highly recommend that you purchase a good digital camera and learn how to use it. You will be able to create promotional materials much faster than with traditional photography.

In addition, you will be able to crop the images easily and color-adjust them to suit your particular needs without having to wait for the professional photographer to do it for you.

Taking good digital photographs will enable you to:

➤ Document everything you create as well as exhibits you're in,

➤ Create your own business cards, portfolios and brochures featuring your images, and save money by printing these materials at your home office,

➤ Update your website easily,

➤ Send photographs electronically (attached to emails) for review by collectors and others, and

➤ Create CD presentations of your work, including online slide shows.

Owning a digital camera and using it has saved me a great deal of money. It has increased my flexibility as an art provider and given me greater confidence in creating brochures and other presentations.

I still recommend, however, that you obtain professional photographs for your postcard invitations. The professional photographer will take a photo of the showpiece and then deliver a 3x5 " color transparency to you. Unless you are using a very high-grade, professional (expensive) digital camera, the transparency will have greater clarity than a digital image and will produce a better result for your postcards. Also consider hiring a professional photographer to take pictures of any pieces that you intend to advertise in a national or international magazine.

Join the art marketing revolution! Put information about yourself, your career, and your artwork on the Internet.

One of my friends is a licensing expert. Recently she surprised me by saying that she never, ever looks at slides. She considers slides to be passé. In her line of work no one has time to review slides, and if you try to submit them, they will be ignored. She explained that her business contacts—companies licensing images directly and licensing agents—review images first via 5x7" photographic prints. They also look at artwork as it is presented to them in brochures showing mock-ups of how the licensed image could be used, such as on placemats, stationery and mugs, or as a poster. When the licensor agrees to license an image, the image is delivered to him digitally on a CD and the colors adjusted to the licensor's needs.

Each and every day, there are opportunities for artists to display and sell their work in non-traditional spaces and in unusual and cost-effective ways. Below is a partial list of potential venues for exhibiting your work:

➤ Arboretums

➤ Art expos

➤ Art centers

➤ Automotive showrooms

➤ Banks

➤ Bookstores

➤ Business mixer locations, chambers of commerce

➤ Cemeteries

➤ Churches

➤ Coffee shops

➤ Community centers

➤ Cruise ships

➤ Dentist and doctor offices

➤ Frame shops

➤ Friends' garages or houses

➤ Gift shops

➤ Grocery and discount stores

➤ Gyms

➤ Furniture showrooms

➤ Hair salons

➤ Homes (including your own)

➤ Hospitals

➤ Hotels

➤ Jazz concerts

POTENTIAL VENUES

If you are like the now-famous "Highwaymen"—the loosely associated group of African-American romantic landscape painters based in Florida—you will even consider selling artwork out of the back of your car . . . along the highway!

- ➤ Law firms
- ➤ Libraries
- ➤ Non-traditional gallery spaces
- ➤ Office buildings
- ➤ Outdoor art shows
- ➤ Physical therapist and chiropractor offices
- ➤ Public buildings
- ➤ Restaurants, high-end
- ➤ Rotary clubs
- ➤ Senior centers
- ➤ Theatres
- ➤ Wellness centers
- ➤ Wine shops
- ➤ Women's (or men's) clubs
- ➤ Zoos

Most successful venues

In my experience, the most successful alternative venues have been:

- ➤ Private homes (including my own)
- ➤ Rental galleries or warehouse spaces
- ➤ Restaurants, high-end
- ➤ Furniture galleries and showrooms
- ➤ Outdoor art shows
- ➤ Medical offices
- ➤ Wine shops
- ➤ Law firms

When you have decided upon a specific locale, you will need to do the following:

Introduce yourself

Notice if there is art on display. If so, introduce yourself to the owner of the establishment and inquire about her procedure for displaying artwork at that location. Make an appointment to show the owners or manager your portfolio. Leave a business card.

Reasons to want your work

Give the owner good reasons he should show your work at his place of business, somewhat like a movie "pitch." For example, my pitch to a local wine shop included telling the owners:

➤ I didn't mind if the shop didn't close for the event.

➤ I would coordinate the entire affair. All they needed to do was to provide the walls and pour the wine.

➤ I would promote the event by approaching the press.

➤ I would generate flyers for the event, thereby increasing the wine shop's name recognition in the community.

Consider both parties' needs

You may have to host your reception on a Sunday afternoon or Thursday night—a slow time for customers. You will need to work with the venue owner's schedule.

The wine shop owners were thrilled to hear that they would be generating additional business on a Sunday when they were normally very slow.

Put the terms in writing

Contracts are good to use, but keep in mind that they can be ignored and are virtually ineffective if you do not have the money to hire an attorney to enforce them.

➤ Leave a written inventory of your work with the owner.

➤ Take photographs of the display for your records.

INVESTIGATING THE SPACE

An important question to ask yourself: "Am I comfortable with the idea of exhibiting my artwork at this location?"

SAMPLE LETTER TO OWNER

Date

Mr. Wine Store Owner
Address
City, State, Zip

Re: Sunday is Fine for Art & Wine

Dear Mr. Owner:

Thank you for agreeing to co-host the *Sunday is Fine for Art & Wine* event at your lovely wine store! Per our conversation, we have scheduled the event for Sunday, September 25, 20XX from 1 - 6 PM. I understand that the event will cost $10.00 per person, payable to you at the door.

I will provide twelve (12) art pieces (list attached) as well as refreshments, and will hang the work myself the day before. You will provide six (6) wines for the tasting. Thank you for allowing me to keep my art on display at your shop for two additional weeks, until Saturday, October 8th.

Please note that I have added the event to my website along with a map to your location. In addition, I have submitted a listing to the weekly newspaper in order to advertise it locally. I would also like to advertise the event and generate excitement with your existing clients. May I create a flier about the event and leave it at your location, perhaps near the cash register?

Thank you so much again for agreeing to co-host *Sunday is Fine for Art & Wine*. I am excited about exhibiting my artist's work at your establishment. I will call you soon to finalize our arrangements. If you have any questions, please feel free to contact me at XXX/XXX-XXXX.

Sincerely,

Name

➤ Get the owner or manager to acknowledge in writing that he has a display of your work at his location. (An email is fine, but something with an original signature is better.) You could have him sign the inventory list.

➤ Create a simple one-page contract, which acknowledges her "hosting" of your art display. For places where you know the owners, simply write a letter acknowledging the dates and hours of the show, with notes about the times you plan to hang and dismantle the exhibit, the nature of the exhibit, the financial terms, and an art inventory list. With a brief phone call, confirm that the information was received and is correct and that you are both clear as to the terms. (Some exhibit locations have a one-page preprinted or pre-formatted contract that you can use.)

In order to write your letter confirming your exhibit and reception, you will need to be able to answer the following questions:

➤ What are the estimated costs of holding an event at that locale?

➤ How long can you keep the work up at that location?

➤ What percentage of sales, if any, do they charge to host your exhibit?

➤ What are the exact dates and hours you will be hanging the work, as well as the exact dates and hours you will be dismantling?

➤ Can you hang any art without frames?

➤ Who is going to hang and light the artwork?

➤ Who is going to pay for your reception?

➤ What are you serving at the reception?

➤ Who is going to bring the food and drink to the location?

Questions to pose to the space owners

➤ Are parking places available for guests?

➤ Will there be additional personnel to help you during your reception? Can you hire extra help?

➤ Who will collect the money from sales?

➤ Who will clean up after the reception?

Once the display is hung, I take digital photographs of it for my records.

➤ Can you bring your clients to the location any time or only during certain hours?

➤ Can you use their credit card machine? If you use their machine, what percentage will they charge you?

➤ Does the establishment have a newsletter or website where they can list the event?

➤ Does the establishment have a mailing list that they would let you use to promote the event?

➤ Do they have a spot at the location where you can post information about yourself and the art display?

INDOOR VENUES

Successful indoor venues have certain traits in common:

➤ A good layout or flow, enabling clients to interact with the art

➤ Good lighting so clients are able to see the work easily. Some restaurants have inadequate lighting for art because they are trying to create a "mood."

➤ Ample parking. Clients need to feel comfortable parking their cars.

➤ Helpful, friendly staff on hand to answer questions, hand out brochures and assist you in making sales

➤ Standard operating hours, including weekends, when people are out and about

➤ Good security. They lock up at night and are located in a good area.

➤ Regular clientele

Take notice of art wherever you go. If you like a space and there is no art on the walls, ask if your art could be displayed there, even for a week.

OUTDOOR VENUES

Share and save: Consider sharing a booth.

Many artists have great success at outdoor art shows. If you produce high-end, expensive or large work, however, an outdoor event may not prove successful because the attendees tend to be more casual art buyers. People at these events will, very often, purchase something they can fit into a bag (jewelry, prints or small sculpture) but are not necessarily interested in expensive or cumbersome pieces that cannot be transported easily as they walk through the show.

You will probably need to participate in outdoor shows regularly to make it profitable. Over time, you will learn the most effective strategies for working at each location. Consider:

Clients' physical limitations
As they shop in the outdoor setting, can they take the art with them that day? If not, you will need to offer to ship the work to them or to deliver it to your client's hotel, home or office.

Product line
Is your work eye-catching? Can your clients see your work from across a large area, such as a park? Will it draw them into your booth?

Emotional stamina
How much do you really want to hear about your work? People tend to be very candid when they evaluate art in an outdoor setting.

Display
How much can you display? How much do you want to display? Is there a way to hang the work or place it on a table or podium?

Booth set-up
Do you need a chair, or is one provided? Even if you do not need a chair, an elderly person visiting your booth might need one. It would, therefore, be a good idea to have one for yourself and one for a guest. Do you have to bring your own portable walls or racks, or will they be provided?

Safety and security
This includes a way to keep your receipts and money safe whenever you need to leave to get food or visit the restroom.

Successful outdoor locations have the following traits:

➤ The show is located in a place where hundreds of tourists and others are likely to come and browse throughout the day.

➤ The show is well advertised.

➤ The event is scheduled regularly so you can return year after year, month after month, or week after week.

➤ Your booth is located near the food and drink but not directly next to it.

➤ You are able to load and unload the artwork without walking miles to get to your booth.

Checklist

When I was a production coordinator in the film business, before leaving for location, I reviewed a list of items that I thought I would need to do the job. The end result—a portable production office. That list is very similar to the one I use now and includes many things that artists also need to set up an outdoor display:

➤ Comfortable shoes

➤ A hat with a broad brim

➤ Sunscreen

➤ Bottled water

➤ Small snack, like an apple or energy bar

➤ Breath mints

➤ Extra sweater or coat

➤ Two plastic folding chairs

➤ Cell phone

➤ Roll of tape

➤ Blank notepad and pens

➤ A small emergency kit with moist towelettes and bandages

➤ Roll of toilet paper or box of tissue

➤ A supply of business cards

➤ Credit card imprinter and slips

➤ Portable walls or podiums for setting up displays

➤ Portable table with folding legs and clean tablecloth

➤ Hooks or other means to hang and display work

➤ A canopy or covering (may or may not be necessary)

➤ Your full portfolio for reference

➤ An ample supply of brochures

➤ Easels, if needed

➤ Bins or other display items

➤ A guestbook

➤ Seller's permit; business license and ID if required

➤ A large sign with your logo or name

➤ Wrappings for sold work

➤ A good attitude, especially needed when working an 18-hour day

WORKING THE STREETS

BY CAROLE WHITMORE

I live and show in Santa Fe, New Mexico. With this location comes the advantage of a very active art market. Higher-end artwork can be and has been sold from sidewalk shows in Santa Fe. Usually medium to lower price ranges sell more consistently. People generally trust the quality of work sold by a gallery and are more cautious about buying expensive work from an outdoor show. Many well-known artists have started their careers in the outdoor venue. It is a good way to be seen and to sell your latest creations. Life on the streets is exciting. You never know who will come into your booth and make your day. As one of my friends so fondly puts it, outdoor artists "work the streets."

As street artists, we have many advantages:

➤ We get to meet our customers, sometimes creating long-term friendships.

➤ We get to "talk art," be it with a client or our fellow exhibitors.

➤ By selling directly to the public, our reward is immediate. We have the thrill of being part of the final critique of our work—the sale.

➤ We can paint what we want, try out new ideas, and sell at prices we choose.

➤ We can try new sales techniques, new media, and new publicity ideas.

Sales depend a lot upon outside forces, such as the economy, weather, and number of visitors. One of the drawbacks to doing outdoor shows is the weather. I have been hailed on, rained on, and snowed on. I have stood in ankle deep water during a rainstorm while scrambling to protect my work. I have felt like Mary Poppins while hanging on to the corner of my booth during a gust of wind. There is nothing like having a waterproof booth and a good number of weights to keep you dry and grounded.

All in all, I love the show season. I do the shows that I feel I need to do to make a living. I love nothing more than selling someone his first piece of art or having a customer with limited disposable income make the decision to purchase a painting. What a grand feeling!

TRAITS OF A SUCCESSFUL OUTDOOR ARTIST

Carole Whitmore, author of the previous story, creates lovely oil paintings featuring Santa Fe and the surrounding area. Her selling season runs from May through October. She exhibits at 12 to 14 shows each season.

Carole exhibits her work in a booth in downtown Santa Fe on Saturdays and Sundays, including Memorial Day and the weekend before July 4th, but avoids Santa Fe's biggest art fairs—Indian Market and Spanish Market—that are dedicated to celebrating the work of the indigenous peoples of the region. Her price range is $195 for a 5x7″ original, up to $2,500 for a 40x40″. Most of her sales are in the $300-800 range.

Carole, whom I have known for 20 years, has been very successful selling her work at outdoor shows because she is:

Enthusiastic about her artwork

Consistent in creating quality works

Skillful at describing and selling her work

Prepared with excellent backup materials—website, brochures, business cards, etc.

She also offers her clients artwork at affordable prices and creates compelling subject matter that is appealing to tourists who visit the area. It also helps that Santa Fe is the third largest art market in the country. People go there year after year solely to buy art, including hers!

Polybags

Polybags come in a variety of sizes, are transparent and will protect your artwork. If you sell your work unframed but matted and the items are small to medium in size—greeting cards, 8x12″ prints, matted 18x24″ photographs or rolled posters—you might wish to consider using polybags to cover your pieces. Polybags can be reused. Shrink-wrap can warp the item you are protecting and is generally not reusable.

PaperMart
5361 Alexander St, Los Angeles, CA 90040
800.745.8800
www.papermart.com

Impact Images
4919 Windplay Dr, El Dorado Hills, CA 95702
800.233.2630 916.933.4700
www.clearbags.com

Labels

I highly recommend that as you prepare your work for sale, you put labels on the back of each piece to identify it for future generations. If a friend of a collector of your work loves your work, he can easily contact you from the label on the back.

Your labels would include the following information:

➤ Title

➤ Medium

➤ Size

➤ Copyright symbol and the year the piece was created

➤ Your name

➤ Website

➤ Telephone number

SHOW RESOURCES

Chapter 3

Promotion on a Limited Budget

Making a penny scream
Cost-effective promo mailers
Dealing effectively with the press
Cross-promotion
On a shoestring
Competitions

The number-one secret to successful marketing is to choose a set of simple and effective marketing activities and do them consistently. Susan Urquhart-Brown

MAKING A PENNY SCREAM

In film school I was known as "The Queen of for Free and for Cheap." Like my fellow producers in film school, I had virtually no budget with which to produce my student projects. At the time, the major requirement for producing a student film was to stay within the budget of $1,200 per production. Out of that budget, each producer had to obtain permits, pay location fees, buy batteries and incidentals, feed an entire crew for five days and build a rather elaborate set.

The school provided the camera and a few lights. The school also had a wonderful working relationship with the Screen Actors Guild (SAG), so we featured professional actors in our projects without having to pay any fees out of our miniscule budget to cast them. If we went over our allotted $1,200 budget, however, we got a serious and very embarrassing "chewing out" by the coordinator in charge of productions, and the whole school would hear, within minutes, how little control we had over our production.

As a consequence, we learned to make a penny scream. We learned where all the best, cheap, bulk food was to be found, how to tap into public power when necessary, and how to finesse filming on the fly, using an old wheelchair as a dolly (which the school never seemed to have on hand). Like my classmates, I was the producer, caterer, costume mistress, grip, location manager, psychiatrist, set dresser, fill-in boom operator, and janitorial crew. I was known for getting amazing things for unheard-of rates, including a fire engine from the Hollywood Fire Department, along with an entire handsome firefighting team, for two dozen cookies. On the same production, I persuaded a blue-screen special-effects company to provide an entire evening of blue-screen for $150. The blue-screen company included the use of the blue screen itself and all the equipment that went with it, three hours of a trained operator's time, equipment pick-up and delivery, and insurance on the production for the day.

My film school production experience taught me some valuable lessons—lessons that I have applied to the art business. Mainly, I learned that the more money one puts into an exhibition or to promote an artist doesn't necessarily mean that the artist's opening will be more successful.

As I manage my gallery without walls, I keep in mind this training and look to three cost-effective ways to promote my artists:

➤ Postcards

➤ Press

➤ Cross-promotion

POSTCARDS

Your postcard announcements (showcards) must be:

➤ Striking

➤ Able to withstand the post office's sorting procedures

➤ Cost-effective

Printing cards

I do not print my cards on my office printer, nor do I recommend it, even though I print my business cards and brochures on my office printer. I always use a professional printer for my showcards for three reasons:

➤ My office printer cannot handle heavyweight paper.

➤ My office printer, though very high-quality, cannot create as rich and crisp an image as I desire for the show card.

➤ Printing 1,000 cards on my office printer is not cost-effective. I once figured out how much it would cost for two color cartridges and heavy card stock (enough to print 1,000 pieces) and factored in my time printing. I concluded that it was actually less expensive as well as nicer quality to have them printed by a professional.

Front of card

A clear, crisp, colorful, well-composed, and recognizable image should be used on the front. Everything depends upon people being captivated by this image. Collectors will choose to attend or not depending upon their reaction to the front image.

COST-EFFECTIVE PROMOTIONAL MATERIALS

Check with the post office regarding their requirements for sending postcards through the mail.

Back of card

➤ Clear text stating where and when (what day of the week and time of day) the reception and exhibit are taking place, in a font that is big enough to read easily

➤ Contact information with phone numbers where people may obtain more information in advance of the opening reception, as well as a website with more information about the artist and an email address

➤ A note identifying the artist and the postcard's cover art

➤ Enough space to write a short, personal note to the invitee

DanielakArt – A Gallery Without Walls
Presents

A L L I E D A N I E L A K
Don't Box Me In

Reception:
Sunday, March 3, 20XX 5 – 8 p.m.

Crown City Gallery of Feline Art
XXXX Raymond Avenue
Pasadena, California 91105
Gallery Phone: (626) XXX-XXXX

Exhibition: March 1-30, 20XX
Gallery Hours: Tues. thru Sun. 9 a.m. – 5 p.m.

DanielakArt: 626-XXX-XXXX – www.danielakart.com

Cover Art by Allie Danielak "My Backyard" Oil 24x48"

The Crown City Gallery of Feline Art
XXXX Raymond Ave.
Pasadena, CA 91105

NOTE: YOU NEED TO PUT THE ADDRESS HERE – NO HIGHER, OTHERWISE THE POST OFFICE WILL SEND THE CARD TO THE GALLERY INSTEAD OF TO YOUR CLIENT!

Check with the post office regarding their requirements for sending postcards through the mail.

A WINNING POSTCARD

The most effective single piece of advertising that I've ever done was with the postcard that artist John Paul Thornton and I created for his one-man show—Bearing Witness—which was held at the Fine Artists Factory. John Paul's showpiece, which we featured on the cover of the card, was a compelling, seven-foot-long oil painting depicting a traditionally-dressed Japanese wedding party. The painting was quite stunning—excellent color and composition—and it reproduced very well. Three months in advance of the opening, we ordered jumbo-size postcard invitations featuring the painting. Right after we received the cards, John Paul and I sent them out (as well as handed them out personally) to our key clients and to members of the press. I also gave several hundred of them to Mark Wood, owner of the Fine Artists Factory, to make them available at the gallery where the exhibit would be held. This led to the following:

➤ Pre-selling the showpiece for $13,000 to one of the artist's existing clients. The client, who had never seen the original, was afraid the painting would sell prior to the opening and did not want to wait to buy it. The painting was sold, therefore, solely on the basis of the postcard invitation.

➤ Two newspaper articles, including one critical review of the show

➤ Fabulous attendance—over 250 people—at the reception

➤ Connecting with the representative of a major art magazine, who picked up the card at the gallery and attended the event because she loved the card

➤ A great write-up about our success with this particular postcard appeared in Modern Postcard's E-Newsletter, which was sent out to over 50,000 of their clients, entitled "The $13,000 Power of Postcards."

A vertical card with the image on one side and the information on the other, mailed in an envelope, might look like this:

Please join us for a memorable evening

Don't Box Me In

Allie Danielak, FFA

Sunday, March 3, 20XX

5:00 - 8:00 p.m.

Crown City Gallery of Feline Art
XXXX Raymond Avenue
Pasadena, CA 91105

Refreshments Will Be Served

Information: Margaret Danielak
DanielakArt – A Gallery Without Walls
626-XXX-XXXX or email <_____>

Exhibition curated by Smokey

Cover art by Allie Danielak
The Garden in Spring Oil, 48x24"

Postcard printers

Modern Postcard
1675 Faraday Ave, Carlsbad, CA 92008
800.959.8365
www.modernpostcard.com
Great quality and excellent turnaround

Mitchell Graphics
2363 Mitchell Park Dr, Petoskey, MI 49770
800.583.9405
www.mitchellgraphics.com
Great prices and service

DEALING EFFECTIVELY WITH THE PRESS

Dealing with the press includes knowing how to write a good press release about your exhibit.

You will need to build a body of local press clippings to prove to editors and art writers at national publications that you are worth writing about.

OBTAINING PRESS COVERAGE

➤ Buy local newspapers and search online to find out which publications cover local art exhibitions.

➤ Phone the editor or writer of the publication to let her know that you will be contacting her via email with information about your upcoming exhibit. Most likely you will need to leave a message. Be clear and courteous over the phone. Sound excited about your upcoming event.

➤ Send the editor via email (often newspapers and other publications will list the email address of their editors on the inside cover or near the table of contents of their publication) a brief cover letter introducing yourself and your exhibit. Find out their deadlines (often listed online or you can call the newspaper to find out their weekly or monthly deadlines) and then suggest to them in what edition you wish your announcement or coverage to appear. Attach a press release (see following example) and two to three images (jpg format) of the art. Describe in your cover letter what you are emailing, along with the medium and title of the work. Make your letter as brief and compelling as possible. Let the editor know how to reach you. Include your phone number, email address, and cell phone number.

➤ The very next day, send the editor the hard version of all that you sent electronically. In addition, send him your show invitation. Let the editor know that he is invited to attend the reception.

➤ If the art editor's office is nearby, visit her in person to give her your press release and show card invitation.

➤ A few days later, follow up on your submission via email.

➤ Look for the piece to appear in the paper. The paper *will not* call to tell you if they have used your material. They will presume that you read their publication.

➤ When your article appears, photocopy it and, if it is good, send copies of it to your mailing list, preferably with a personalized note.

➤ Follow up with the editor by writing him a note—not an email, but rather a formal thank-you note. If possible, have the note include an image of your work on the front of it. (As mentioned previously, I recycle returned show cards. I place one on the cover of the note card I create to write to the editor so that I can reinforce my exhibition and the artist's style in the editor's mind.)

➤ If you live near the editorial offices, take your thank-you note with a bottle of wine (or muffin basket, etc.) to the newspaper's office. Thank the editor in person. Give her the gift and let her know how much you appreciate her support, not only of your work but also of the arts in her community. This last step, formally thanking the arts editor, is most crucial. You will also have a much easier time obtaining coverage in that newspaper in the future, simply because she knows you and your work, and she will feel good that you have taken the time to acknowledge her work.

Remember, no publication wants dead space, and editors are always looking for news. Many times, right before a deadline, an article will get dropped or an advertiser will pull out, leaving the publication with space that must be filled. This is your opportunity to get some free or inexpensive advertising.

If you thank the editor, he will never forget you.

SAMPLE PRESS RELEASE

FOR MARCH 1, 20XX *FOR MARCH 1, 20XX*

CONTACT:
Margaret Danielak, Owner
DanielakArt - A Gallery Without Walls Phone: (626) XXX-XXXX
Email: <_____> Web: www.danielakart.com

DON'T BOX ME IN
A SOLO EXHIBITION BY AWARD-WINNING FELINE ARTIST
ALLIE DANIELAK

DanielakArt - A Gallery Without Walls is pleased to present **DON'T BOX ME IN,** a solo exhibition of oil paintings by award-winning feline artist **Allie Danielak**, taking place at the Crown City Gallery of Feline Art in Pasadena, California, March 1 - 30, 20XX.

DON'T BOX ME IN embraces the theme of female emancipation from the domination of male cats. Symbolic paintings of females sharpening their claws, guarding open windows and investigating flowerpots (broken on the floor) are featured in this colorful exhibition. Issues of territory and belonging are examined in several paintings depicting Allie's neighbors relaxing at home in their gardens, patios and perches. Portraits of the artist's female friends, some former strays, will also be included.

Several new pieces depicting kittens from Allie's famous, scratchy "Cycle of Life" series will also be featured. The viewer sees innocent white kittens, unaware of the hostile world around them, grooming, playing and sleeping.

Last year, Allie Danielak won first prize in the annual Feline Painters of America competition. She is a master signature member of The California Society of Feline Painters, Female Feline Artists (FFA) and Painters for the Understanding and Protection of Strays.

DON'T BOX ME IN may be viewed at the Crown City Gallery of Feline Art located at XXXX Raymond Avenue, Pasadena, California from March 1 through March 30, 20XX. The reception is Sunday, March 3 from 5:00 – 8:00 pm. Contact DanielakArt at (626) XXX-XXXX. Visit www.danielakart.com for further information.

-- ### --

For one exhibit held at the local culinary school, I obtained what looked like a quarter-page color ad in the weekly newspaper featuring two images from my artist's show. I simply submitted information about my artist and the show to the arts editor two weeks before the newspaper's deadline, along with several photographs of the artist's work. I was unaware that a company in town that was scheduled to pay for an ad "fell out" at the last minute. (They did not pay their ad bill on time.) The newspaper thus had a blank space to fill. They loved the artwork I had submitted and needed to fill that space in their arts section quickly to meet the deadline. My clients thought we had paid for a big color ad for the show, but it was actually free!

Layout for press releases

➤ The first paragraph describes the event.

➤ The second paragraph describes what the exhibit is about.

➤ The third paragraph describes something new and why we should care.

➤ The fourth paragraph lists the artist's educational achievements and awards, again emphasizing why we should care.

➤ The fifth paragraph wraps up all the information about who the artist is and where and when the event is taking place.

Press and media people will not follow up with you. You will need to follow up with them.

Media

I have a four-inch binder full of press clippings for the exhibitions that I've held over the past five years. I think of press coverage as free advertising—actually better in many ways than paid ads, since people react to press coverage differently, perceiving the artists and their events as newsworthy.

CROSS-PROMOTION

Cross-promotion with other businesses is a very low-cost way to gain more exposure for your artwork and enhance your career. Nowadays, both large and small businesses are looking for cross-promotion opportunities to reduce costs and gain access to new customers. As an artist, you can do the same.

Offer to co-host a reception for your clients in a store that is open—but has slow traffic—on a particular day or night.

ART TASTINGS

Our local wine shop, for example, is open on Sundays, but the shop has few clients on that day of the week. In exchange for providing art for their otherwise bare walls, I "pitched" an idea to the owner of the shop. I offered to co-host an "Art Tasting Event." I invited my clients to come to the shop on a Sunday afternoon. We would match the subject matter of the art with wine regions, thereby directly matching the art with the wine. The wines were selected by the shop on the basis of cost—a range was represented—and their relationship to the regions represented in the art—Southern France, Northern Italy and Northern California. I encouraged the owner of the shop to use wines he was promoting during that particular month so he could increase sales of his targeted inventory. Naturally, exhibiting artists attended the reception and were able to answer questions about their work as well as enjoy the reception. Sixty-five of my clients attended the event. Each attendee paid a reduced cover charge to the wine shop for the wine tasting—business that the wine shop would not have otherwise enjoyed on that day. Much to the shopowner's delight, my clients were serious wine drinkers, so many of them, who had never visited the shop before, purchased bottles and even cases of wine on that day. In addition, one of my artists secured a commission—something I'd been discussing with the client for over a year. The shopowner and I were pleased with the outcome, especially since it was very inexpensive to produce. In addition, my clients told me they had a wonderful, memorable time.

The following are some creative, as well as inexpensive, ways to promote your exhibition. Use your own creativity to think of how you can promote your personal style of art.

Use your website. Put an announcement of your event on the first page. Create a link to a map of the location so people can download it easily.

Use your answering machine. Let people know the address where the work can be seen by including the information on your outgoing message.

Ask friends and clients to forward emails to their contact lists to announce your event.

Give an extra invitation to your existing clients so they can "invite a friend." Be sure it's clear to your present clients that they can bring a friend or relative to the reception. Handwrite this on the invite you send to them.

Tell your neighbors and co-workers. Post an announcement at your day job.

List your upcoming event on a flyer posted at another event.

Recycle show cards. Use returned invitations for other purposes—put the card on folders that you submit to editors or collectors, for example.

Document what you do. Take notes and photographs. Videotape your display. Keep your notes in a binder. Write articles about the show and keep any press clippings to promote other events and your overall career.

ON A SHOESTRING

COMPETITIONS

Consider entering local competitions as you begin your career.

Many artists use competitions as a way to expand their audiences. Some artists have even become famous by entering and winning competitions. Winning the grand prize in a major national competition will give you greater name recognition and visibility. Generally, you will receive publicity about your work, furthering your career.

There are many art competitions to apply to, but not all of them will help you make sales or stimulate your art career. I recommend that you research each one's purpose. Be choosey.

Find out which competitions are longstanding and prestigious. Make a list. Enter the ones you determine to be the most useful to your career. Entering contests will also help you evaluate your work—to see where you stand with people who do not know you.

Competitions

American Watercolor Society
Annual International Exhibition
47 Fifth Ave, New York, NY 10003
212.206.8986 www.americanwatercolorsociety.com

California Art Club
Annual Gold Medal Exhibition
PO Box 92555, Pasadena, CA 91109
626.583.9009 www.californiaartclub.org

Museum of the American West (formerly Autry Museum of Western Heritage)
Masters of the American West Fine Art Exhibition and Sale
4700 Western Heritage Wy, Los Angeles, CA 90027
323.667.2000 www.museumoftheamericanwest.org

Even if you don't win a competition but are accepted into the show, you might sell that piece or obtain a commission from a new collector.

National Watercolor Society
Annual International Exhibition
915 S Pacific Ave, San Pedro, CA 90731
310.831.1099 www.nws-online.org www.nws-web.org

Oil Painters of America
Annual national and regional exhibitions
PO Box 2488, Crystal Lake, IL 60039
815.356.5987 www.oilpaintersofamerica.com

Chapter 4
Taking Care of Business

Record-keeping
Sample sales chart
Insurance coverage
Merchant status
Sales tax

If you can count your money, you don't have a billion dollars. J Paul Getty

RECORD-KEEPING

Keeping good sales records is essential in any business. Knowing which piece has sold and to whom enables you to plan your marketing efforts more effectively. You will know that certain people, for example, like to collect smaller works. You can then call or write to them once a piece of that size becomes available. Your collectors will think you are a genius for remembering exactly which artwork of yours they own. They will also get the message—you really value your work and to whom it is sold.

THE MYSTERY OF MYSTERY GATE

My father created three paintings of the same subject. He called each one *Mystery Gate*. Two of these paintings were acrylics and one was a watercolor. After the paintings sold, we could not figure out exactly which ones sold to whom. We later called this episode "The Mystery of Mystery Gate." Was it the watercolor or one of the acrylics that sold to our friend in Albuquerque? Was it the watercolor that sold to those collectors in California? Each of the acrylics was a different size and looked slightly different. My father didn't take photographs of these as he normally did, so we will never know who bought which. It's still a mystery!

Binders

Organize your sales records in binders.

➤ One of the best ways to keep good records is to create a personalized receipt for the purchase.

➤ Give people two receipts, one the minute they purchase it—a handwritten receipt or credit card slip. Within two weeks, send a thank-you letter and personalized receipt.

➤ Artists often create works that are similar—part of a series, perhaps. It is best not to give these the same title. Attach a photograph of the image you sold and keep it with your sales receipt so you know exactly which piece sold, when it sold and to whom. This is especially important information to have available if you are being considered for a retrospective of your work.

➤ Put the thank-you letters, receipts and photographs of your sold work in a binder marked "Sales," with the most recent sales receipts on top.

A running total

You should also keep a running list of all of your sales. Keep the list in QuickBooks, or a simple Excel or other spreadsheet format, and update it as you make sales. This practice will assist you at tax time.

As much as 80% of your future business will be from your current clients. Know your sales history. It will help you become more successful in client relations.

SAMPLE SALES CHART

Date	Title	Size	Med.	Framed ?	Sales Price	Artist 70%	Dealer/ Gallery or Venue 30%	Taxes 8%	Notes
1/5	**The Red Barn** Client: J. Olsen	18x24"	Water-color	Yes	600	**420**	180	**48**	Follow-up from December Event (Credit Card)
1/7	**His Big Ego** Client: G. Goodwin	48x48"	Oil	No	4,000	**2,800**	1,200	**320**	Art Tea (Check)
1/7	**Prima Dona** Client: C. Kravitz	18x24"	Oil	Yes	1,800	**1,260**	540	**144**	Art Tea (Credit Card)
1/7	**Sold Out** Client: L. Johnson	24x18"	Oil	No	2,400	**1,680**	720	**192**	Art Tea (Credit Card)
1/8	**Lemon Grove** Client: R.. Clark	12x12"	Acrylic	No	400	**280**	120	**32**	Private Sale (Cash)
	TOTALS:				**$9,200**	**$6,440**	**$2,760**	**$736**	

INSURANCE COVERAGE

I have a Business Owner's Policy ("BOP") from Hartford Insurance, which covers any damage as I transport artwork from one location to another. Some artists and dealers carry a Fine Art Dealer Policy. Unfortunately, neither one of these types of policies covers everything you might need when exhibiting in an alternative venue. Speak to your insurance agent as to your particular needs. Do not rely on your homeowner's or renter's insurance policy to cover your inventory, at your home or in an alternative venue.

➤ Do you have insurance for your artwork?

➤ If someone is representing you in an alternative space, do they have insurance? If so, what kind?

➤ Do the owners of the alternative space have insurance? If so, what kind?

➤ Can the owner of the establishment where you are exhibiting your work list you and your inventory as an additional insured on her insurance policy?

Psychologically, many people think it is both easier and faster to buy with a credit card. Some even feel "safer" paying with a card.

Why?

➤ They may not actually know the exact balance in their checking account.

➤ Credit card companies insure against fraud or loss.

➤ Some people wish to acquire frequent flier miles, and using their card to purchase art enables them to reach that goal.

➤ Some people might not want their spouse or partner to know when they have purchased something or how much they have spent, especially if it is a gift. Paying with one's credit card can make the transaction more private.

Most importantly, people tend to spend more if they can pay with a card as opposed to a personal check. As an art provider, you will benefit greatly if you set up a business bank account and tie it to a "merchant account" so you can accept credit cards.

Payment processing companies offer merchants several options. The most frequently used are:

➤ A machine that plugs into a phone jack

➤ A wireless device that uses radio signals

➤ A card imprinter or low-tech manual "slider"

➤ No machine at all; you just dial in for your approval on any phone.

Card imprinters

A card imprinter works best for artists who sell their work in different locations. At an outdoor show, you will probably not have access to a phone jack, for example, and there may be interference if using a wireless network.

Another great advantage of using a card imprinter (slider), or at least having it on hand for backup, is that it can protect you somewhat against charge backs. Some merchant service companies even recommend that you use a card imprinter in addition to a wireless or electronic device, to get the client's original signature to have on hand in the event of dispute.

MERCHANT STATUS

Having a low-tech credit card imprinter—a slider—will enable you to transact business anytime, anywhere. You can simply handwrite the credit card number, which is easy enough if you only have a few transactions and are not strained for time.

I have used a manual credit card imprinter—slider—for four years. I simply keep a supply of sales slips with me and use them with my machine as needed. I give the client his receipt, *being sure to black out all but the last four numbers* (just like an automated receipt) so if anyone were to find the client's receipt, they wouldn't be able to see the complete credit card number. I then attach my copy of the sales slip to a regular size piece of paper and put it in my sales binder.

Later on, from my office, I phone my payment processing company and give them the information so that the funds can be transferred into my business account, a simple process. I then check my bank account a few days later to make sure the money was deposited into my account properly.

Credit card processing companies charge for the following:

➤ A first-time set-up fee. They will check your personal credit history and make sure you do not have a criminal record and have good personal credit.

➤ A fee for buying or leasing the machine

➤ A monthly charge, usually about $20

➤ A percentage of each sale, ultimately based on your sales volume for that month—1.8 - 5% of each transaction

➤ An annual fee ($50-100)

➤ Miscellaneous fees (which can bring your monthly percentage rate closer to 4 - 6%)

Your bank, in addition to the credit card company, may charge a fee for setting up the merchant account. Remember, most bank charges on your business account are tax-deductible.

Having your business be able to accept credit cards—having merchant status—can mean the difference between making a sale or not.

The first year I accepted credit cards, I made very few sales for which merchant status was needed. I wondered if I shouldn't cancel the service since all of my clients paid via check. During my most recent exhibition, however, I sold 10 pieces; eight were purchased with credit cards. Several clients mentioned that they wanted to purchase via credit card in order to obtain frequent flier miles. It became effortless for them to acquire that second (and third) piece.

SALES TAX

Selling to someone who lives out of state but is buying from you in person in California is taxable, unless you ship the product directly to their home state.

In the state of California (as in most states—Oregon being one exception), retailers (that's you!) collecting monies from consumers for products must collect tax on sales (except for groceries and miscellaneous other goodies). Art is definitely taxable.

Most states require a resale license—a seller's permit—currently obtained free from the Board of Equalization. You will need to have this permit no matter where you are selling from: your house, a street fair, a coffee shop, etc. When you are selling from a gallery, the owner of the gallery uses her permit and collects the taxes. She is then the retailer and you are the wholesaler.

When you collect the tax from your retail sale, you eventually remit those funds to the Board of Equalization. The Board of Equalization will provide you with a simple form to use when remitting those funds. The Board will inform you of any changes in the tax rates and will even provide you with some free assistance such as advice, seminars and invitations to small-business fairs.

You always have the option of letting your tax professional prepare the sales tax forms. This might be a good idea the first time you remit sales taxes; then you will have a format to follow in subsequent years. If you keep good records of each transaction, this form should be simple to fill out.

If you remit tax monies annually to the Board of Equalization, the money will be due to the state January 30 of the following year. Be sure to put aside all taxes you collect so you won't be in a bind at the end of January. The Board charges a heavy late fee, as well as interest.

Sales taxes vary from district to district, so be aware of district tax rates.

RECOMMENDED READING

Art Marketing 101 by Constance Smith

Legal Guide for the Visual Artist by Tad Crawford

Chapter 5
Alternative Venues

Pros of alternative venues
Cons of alternative venues
Rental galleries

To create one's own world in any of the arts takes courage. Georgia O'Keeffe

PROS OF ALTERNATIVE VENUES

Show your artwork on a regular basis—familiarity inspires sales.

Many collectors are thrilled to get to know the artists whose work they admire. This is one of your advantages when exhibiting and selling your work in an alternative venue.

Some artists may think that it is demeaning to exhibit and sell their work in an alternative venue. They may think that they will be considered less successful if they sell outside a gallery and may even believe that their work will be less collectible if they sell it in this manner.

Many successful artists (including the famous French Impressionists) got started by exhibiting first in an alternative space. In some cases, being outside the gallery makes an artist's work more desirable because it was displayed in an unusual way, such as Christo and Jean Claude.

Certainly, there are pros and cons to exhibiting outside a traditional gallery. Below are some thoughts about the issue from each side of the table:

Non-traditional art buyers and collectors—the untapped market—attend events in non-traditional places. One of my artists holds a major exhibit of her work each fall at a local four-star restaurant. She is one of four artists who are booked each year by the manager. The restaurant, which is quite expensive, is a favorite haunt for several celebrities. During one exhibition, while eating his lunch, a celebrity fell in love with, and then purchased, one of her large pieces. Her abstract pieces, characterized by bold colors and large brush strokes, show and sell especially well in restaurants and other spaces with large walls.

Unique, themed events generate excitement. People feel more compelled to attend a themed event than one which seems to be like so many others taking place.

Cross-promotion is an important factor. Cross-promotion works especially well at law firms and wine shops. These types of establishments attract people who have disposable income, whom you might not otherwise meet.

You can show your work at the client's convenience and on a day or at a time when traditional galleries are closed. I've sold six paintings on national holidays, for example, when all of the local galleries were closed!

Some people will not go to an art gallery because they presume that the gallery staff will be unwelcoming and "snobbish." Alternative venues—wine shops and restaurants—provide a more relaxed atmosphere for potential clients.

EXPOSURE EQUALS SUCCESS!

There's one basic formula for artists: Exposure Equals Success! Artists who want a professional reputation need to have exhibitions so that their work can be reviewed by people who count in the art world. To make a good living, artists must build up a group of people who follow their work, support it, and want to tell other people about it.

For emerging artists, it takes time to build up a mature body of work and develop a professional approach to the business side. Sometimes the hardest thing to do is land that first show. You can't stop trying to exhibit your work just because galleries have turned you down. You have to get your work before the public and you must be creative about finding opportunities for exhibitions. Start in your studio and expand your thinking.

Excerpted from The ACT Workbook for Professional Artists. *©2000-2005 Artist Career Training.*

OF ALTERNATIVE VENUES

One size does not fit all with respect to alternative venues. Find venues that are appropriate for your work.

Collectors

Art collectors do not buy art randomly. They systematically acquire certain pieces, keeping in mind how a new acquisition will fit in with the rest of their collection, which often reflects their passion for a particular style, genre or school of art.

Collectors can buy:

➤ for pleasure

➤ for status

➤ to make a profit

Some collectors buy art for all three reasons. Some even will buy it on a whim if they like it—simply because it brings them joy to acquire it. The art collectors whom I know love to learn about artists—their history, their career—and they find it thrilling to chase down the best work created by those artists. Collectors appreciate being informed about art and are on a never-ending search for "that special work of art" to round out their collection.

Unfortunately, some collectors only buy artwork from traditional galleries or private dealers. As an artist, you are fighting against the traditional way of doing business where high-end collectors acquire pieces through traditional art galleries, at auction, and through well-known art dealers who buy and sell art. Several books about art collecting advise beginners never to purchase art in alternative venues because collectors have not had time to do the research necessary to determine if the artwork is truly worth the price listed—a legitimate concern. Additionally, the art establishment advises collectors never to mix drinking (wine) with transactions because they think collectors are vulnerable when they drink and should therefore wait and do some research before buying the work.

Provenance

In addition, art dealers, auctioneers and gallery owners are concerned with provenance—where the art came from. They believe that acquiring work outside the normal channels is suspect and should be avoided. However, buying directly from the artist makes the provenance easy to verify, which is to your advantage when selling your work directly to such people.

Collectors love to buy art, which is why they have acquired so much art in the first place. If they love the art and can afford it, they will buy it in an alternative space, even online.

Sophisticated collectors are well aware of the risks in purchasing anything, including art. They are aware that there are no guarantees, even with the art that they have purchased through "traditional" channels.

UNCLE RUDY

My uncle "Rudy" admired a painting by a Society of Six painter, Maurice "Murray" Logan, who was his friend and neighbor. (My uncle is a wealthy art collector and knew Logan had been a noted Bay Area painter.) In the early 60s, my uncle admired Logan's painting of a rocky shoreline, which had been painted several years prior, but Logan also loved the piece and did not want to part with it. After discussing the painting for a year in their respective backyards, with drinks in hand, my uncle convinced Logan to part with the piece for what we would say now was a very small sum. A few years ago, Rudy decided to divest his art collection and reluctantly put the Logan up at auction. Logan's painting, which Rudy purchased directly from the artist, sold for over $16,000—an exponential increase from the original sales price. Rudy was quite pleased with the outcome. In addition, the auctioneer, who had only read about Logan, was thrilled to hear all about the late artist from someone who actually knew him.

Press

Most likely you will not obtain critical press at an exhibition held in a rental gallery or any other alternative venue. (To obtain critical press, even for an established gallery, is rather rare).

I was able to obtain a critical review, however, and several lengthy press pieces from the local newspaper about an exhibition I produced that took place at the Fine Artists Factory, a high-end rental gallery and artist workspace in Pasadena. This "rule" may be changing, therefore, depending upon the number of traditional galleries available in a community, the quality of the alternative gallery space, and the attitudes of the newspapers and art reviewers in any given location.

Duration

People might miss the exhibit because of its short duration. Try to keep the work up for at least two weeks to give people a chance to see it. Invite people after the event to meet you at the location so that you may discuss the work one-on-one.

Locations

If an event is successful at a particular alternative venue, try to schedule your shows in the same location during the same month or weekend each year to breed familiarity with the location over time. People like returning to a familiar place.

RENTAL GALLERIES

Artists are often warned never to exhibit their artwork in a rental gallery. At its worst, the rental gallery preys on unsuspecting artists, often artists from foreign countries who are desperate to show their work at any cost in the United States. These galleries make claims with respect to their ability to bring in clientele, to advertise an artist's show, and to the quality of the artwork exhibited, which are often inaccurate. They charge high fees and rarely do anything except rent the space.

Some rental galleries, however, are barely distinguishable from a "traditional" art gallery. The directors of these spaces screen artists for quality and to see if they have a professional attitude and portfolio. They expect artists to display professional-looking work and to mount or frame their work according to certain standards and guidelines. Owners of these rental galleries want the artists to have an opening event, to promote that event, and to be in attendance.

Many traditional galleries have started to charge for receptions and advertising (including website listings), as well as for wall space, in addition to a percentage of sales. Distinguishing one type of gallery from another is becoming more and more difficult.

As an art rep, I've worked with "traditional" galleries as well as one excellent rental gallery. My recommendation is for artists to research both types of galleries in the same way:

➤ Attend an opening event.

➤ Find out how long they have been in business. If they have been in business less than three years, consider passing.

➤ Speak to artists who have exhibited there in the past. Find out if the space worked for them.

➤ Observe the quality of the shows and how well the artwork is lit and displayed.

➤ Speak with the owner, director or manager. Learn something about her background selling art.

➤ Ask yourself if the space and the people are welcoming.

➤ Spend some time at the gallery on a Saturday or Sunday afternoon. See how the personnel handle people who walk in the door. Determine if they are effective at selling artwork.

Remember, in a rental gallery you will have to do the work—promote the exhibit, provide refreshments, etc.—just like you do at any other alternative venue.

Do not dismiss the idea of utilizing a rental gallery.

Many clients do not even know in what kind of gallery they are visiting. If they feel comfortable and like what they see, they might consider purchasing. I simply consider a rental gallery to be an alternative venue with advantages for exhibiting and selling art from a good one. In fact, I'd rather work with a lovely rental gallery where I can control most of the variables, and pay a set fee, than work from a more traditional gallery where my artists and I are charged for every little thing, and the staff consists of snooty or ineffective salespeople.

Chapter 6

Themed Events

The "Art Tea"
Event names

The best way to predict the future is to invent it. Alan Kay

THE "ART TEA"

A themed art event is an event where everything—all of the elements of the event including decorations, invitations, food, wine and art refers back to your featured topic.

When I was first getting started as a rep, I wanted to do something bold to kick-start sales of my artist's work. At the time, I did not know the owners of many businesses and could not afford to rent a space, so I decided to produce the equivalent of an open studio by hosting a Ladies' Tea—an "Art Tea"—at my home. The event was easy and inexpensive to produce, and the sales and opportunities that came from hosting this event were quite wonderful.

Over the years, I've continued to host Art Teas. In fact, each time I sign a new artist, I hold one to introduce my clients to the new artist's work and to judge their overall reaction. To make it more compelling to attend, I select a new theme for each Art Tea. I am now producing more specific themed events: Art Tea Networking Events for Women and Designer Art Teas for Interior Designers.

As an artist, you could host your own Art Tea. Below is a list of recommendations to help you create the best possible event:

Schedule wisely

Schedule your event on a good day and time that is convenient for your guests. Remember that Saturdays are difficult for many people since they work during the week. My Art Teas, therefore, take place on Sunday afternoons from 1 - 5.

Set a pretty table

Break out the goodies for your guests. My grandmother's china and silver trays work well. An antique silver teapot is used for serving tea and provides a charming centerpiece for the table.

Have a recognizable theme

For my first Art Tea, my husband and I were planning a trip to Paris, so "Paris" became the theme. An invitation that reflected this theme featured a lovely painting of Paris on the cover. The original painting hung near the serving table so everyone would see it. (This piece sold.)

Invite a few collectors

Do not invite every one your clients—be selective. Inviting a smaller number of well-connected people is more important than having a large quantity of people. You want to be able to give individual attention to your guests. If too many people attend,

Themed events intrigue clients.

you will be distracted. Twenty-seven women were invited to my first event. Five women were from out of town, so I did not expect them to attend. Of the twenty-two remaining potential guests, fourteen attended, and four made arrangements to come by at another time. Of the four who made other arrangements, two bought paintings.

Think two-by-two

Think of yourself as "Mrs. Noah" of Noah's Ark fame and pair up your guests two-by-two. I invited two interior designers, two radio producers, two curators, etc. to my first event. When speaking with guests before the event, I mentioned that I was inviting their "counterpart," the person whom I believed they would most enjoy meeting. In some cases, the guests knew each other by name since they were in the same profession. Knowing to whom they were going to be introduced gave each person an added incentive to attend.

Handle men with care

Despite the invitations being clearly addressed to women, several husbands RSVP'd. I called them back and politely explained that the Art Tea was for women only. I made a point of saying I'd be happy to show them and their spouse the artwork at another time during the week at their convenience, over a glass of wine. The men thought wine sounded better than tea any day, so they accepted.

Be flexible in showing the work

Some of my guests appreciate the fact that I am willing to show the work several days before and up to two weeks after each event. I do not keep the work up indefinitely, however. Art sells better when it is rotated regularly.

Show a broad price range

Showing a variety of artwork at a variety of prices increases your chances of making sales. It is also less intimidating to your first-time clients, since they do not necessarily know the "value" of the art they are seeing. For a Spring Art Tea event, I priced some original work from $40 for small paintings to $900 for colorful acrylic paintings of the Huntington Gardens.

Art Teas tend to be intimate and fuel sales throughout the year.

Provide a memorable hostess gift

As part of making each guest feel special, for my first Art Tea I purchased the Metropolitan Museum of Art's ornamental shoes in two French designs. Even though they were expensive, I felt they were necessary to make the event more memorable and to reinforce my Parisian theme. I simply wrapped up each of the clear shoeboxes with a gold ribbon and attached my card. Each gift was personalized with my guest's name on the back of the card. As each guest left, I handed out a shoe and said, "A little something to start off the year on the right foot." A gift was also given to the guests who were unable to attend but who came by either before or after the event. The shoes were a big hit.

I sold $7000 worth of work at my first Art Tea and have sold an average of $5000 at each of the following Art Teas I've hosted over the past five years. In addition, during the first event, one of my artists secured a two-month solo exhibit at a local restaurant. Another artist secured several commissions. At each of the Art Teas, my expenses have been more than recouped. My guests also tell me that the Art Tea provides a wonderful way to spend a Sunday afternoon.

Themed events can be created around a variety of well-known holidays, locations, people, places, seasons or things. A few ideas:

➤ Fall Harvest: **Beauty & Beaujolais**

➤ Fine Dining: **Great Restaurants**

➤ France, Italy or Spain: **An Evening in Italy**

➤ Flowers or Trees: **Tulip Madness**

➤ Holidays: **Holiday Art Tea**

➤ Valentine's Day: **Sweet Art**

➤ Travel: **The Road Home**

➤ Fourth of July: **Freedom Art Tea**

EVENT NAMES

A themed event helps you keep organized when planning—everything relates back to the theme.

Chapter 7
Successful Events

To do's
Whom to invite
Guest books
Mailing lists
Working with a rep
Ethical practice

Successful people love what they do. Even after other people think they've made it, successful people keep on working. Margaret Danielak

TO DO'S

Post a notice about the event on Internet art boards, blogs, and the local community calendar.

Most people are unaware of the incredible amount of work and planning it takes to produce an annual art event. At a well-planned event, all is running so smoothly—like a good ballet—that no one sees the effort. The artwork is framed, hung, and well lit. The reception table has food and wine, which miraculously appears.

People are unaware that someone had to reserve the location, design the invitations, stuff and mail the envelopes, update the website with exhibition information, obtain the food and wine, light the work, follow up on the press and invitations, set the table, greet guests, make sales, dismantle the show, as well as possibly deliver the artwork to buyers. The goal with all of this activity, of course, is to make it seem effortless, as though the art "sold itself," which of course it didn't.

Each and every time, the process of producing an exhibition reminds me of producing a short film. I have a star who is sometimes late for his own opening. I have art, also the star, that has to be handled carefully and lit correctly. It has to be marketed and sold to the public.

Over time, I've created a checklist to help with this process:

➤ **Set goals with respect to attendance and sales.**

➤ **Create compelling press, show cards, brochures or fliers.**

➤ **Send announcements 2-8 weeks in advance of the event.**

➤ **Become friendly with all of the personnel at the location.**
Get to know everyone's names. I've even sold art to the people who work at the locations of my exhibits.

➤ **Measure the space in advance to determine how many pieces you will need.**

➤ **Estimate how many people will fit into the space.**

➤ **Plan fliers and refreshments based upon projected attendance.**

➤ **Check the lighting at the location.**

➤ **Follow up on the press and invitations.**
Call three days before the event to remind people of the invitation.

➤ **Hang the work.**
It is best to hang at eye level—53-55 inches from the floor to the center of the image.

Create enthusiasm in advance:

➤ Email an announcement to your email list.

➤ Post an announcement of the event on your answering machine, directing people to the location and to your website.

➤ Ask your network of clients to forward email announcements to their friends.

➤ Post the event information, with a link to a map, on the first page of your website.

➤ Post a notice about the event on Internet art boards, blogs, and the local community calendar.

➤ Leave fliers or show cards at the exhibition location several weeks in advance of the opening reception.

➤ Put an announcement of the event on the host's website or in their newsletter.

REFRESHMENTS

During one major art event, I was unable to hang many of the most striking pieces of the exhibition in a large, beautifully lit conference room where the reception was to take place. During the reception, the attendees enjoyed very elaborate food and wine, yet saw less than half of the display, since the pieces were hung in a hallway leading to the entrance of another room.

➤ Move the food and wine to a strategic position right next to, below, on the side of or near the art.

➤ Place the art above the table.

➤ Hang art above the food display.

➤ Move chairs to other parts of the room so that when your guests sit down, they will see the work.

Never hold an art event where the food and wine are located separately from the art. Have the art in full view of the food and wine.

Part of the reason why Art Teas are so successful is that the food, drink and art are all intertwined, almost becoming one and the same. The attendees cannot escape viewing the art. As they sip tea, they "drink" the art. Some of the artwork is small, so they can even pick it up. They are surrounded by it.

Providing elaborate food and drink at an art event sends a message that the reception is a party, not a sales event. You have only a limited time during the reception to make sales. Plan with intention the food, drink and chair placement in relation to the art.

The question I hear often from artists is, "Whom do I invite to my events? I don't know very many people."

Networking

Join local organizations—especially volunteer organizations, sometimes called non-profits. When you become active in community organizations, not just art-related professional organizations, you will be introduced to an entirely new group of potential buyers. Fellow members who join civic groups often do so because they have free time to volunteer, which means they probably have disposable income to buy art.

As you attend events, or volunteer to be on a committee working on a specific project, trade business cards with members and add them to your personal mailing list.

Art groups

Joining art groups is fine too. Some of your artist friends may purchase your work, but artists tend to have a great deal of their own art on hand, and not much room or money to purchase other artists' work. Joining art groups, creating artistic friendships and learning from other artists about opportunities is wonderful, but do not make the mistake of presuming that joining art groups will lead to sales. Art groups are mostly for learning about art and having camaraderie.

Civic organizations

➤ Arts council

➤ Assistance League

➤ Historical Society

➤ Junior League

➤ Kiwanis Club

➤ Lions Club

➤ Museum council

➤ Resident's association

➤ Rotary Club

WHOM TO INVITE

Networking is one of the most important aspects of selling.

Carry extra invitations everywhere before the event. Hand them out to anyone you think would like to attend. The people you personally hand them to will feel special that you took the time to invite them.

➤ SPCA

➤ Theatre/playhouse backstager organization, "Save the local theatre" group

➤ High school alumni association

➤ College alumni association

Your local Chamber of Commerce might have networking events (breakfasts) in which you could participate. Ususally these are monthly meetings. Most of their members are local businessowners, many with empty wall space.

Other invite ideas

➤ Neighbors

➤ Co-workers

➤ Spouse's co-workers

➤ Members of your club; tennis buddies

➤ Children's friends' parents

➤ Members of your church or synagogue

➤ Friends of your current collectors. Write a personal note on your invitation when you send it to current clients to remind them to bring their neighbor or friend. Collectors who love your work are often happy to promote it.

Be sure to leave out a guest book at each of your events. Collect the contact information and add those people to your ever-expanding mailing list to invite to future events.

GUEST BOOKS

I bring a guest book to each and every event that I produce. I prepare the book ahead of time with all the contact information that I hope potential clients will give me (name, address, phone, email). I also encourage people to give me their business card. I bring a small bowl to each event and put a business card or two in it to give people the idea that it is okay for them to toss their card into the bowl. After I acquire cards, I enter the information into a database and then put the business card into my Rolodex. I make notes about where I met them and which pieces the person admired so I can follow up with them.

MAILING LISTS

In order for your mailing list to be effective, you must mail to it several times a year.

Over time, as you host events in alternative venues and build your "gallery without walls," you will acquire hundreds of names and addresses. You will need to have a large Rolodex, or better yet an electronic database, to keep track of them.

Effective mailing lists

Creating an effective mailing list gives you the opportunity to contact interested parties. Though it may seem daunting, acquiring this list, it is actually rather easy. Learning how to use the list effectively is more challenging.

As an artist, you will need to nurture your mailing list. This means that you will stay in touch with your prospective clients by sending out a quarterly newsletter, note, brochure, postcard, or email letter, and then tracking the responses and sales created.

Rule of thumb

Drop people from your mailing list upon request, or after you have not heard from them in any way for four years.

Several years ago, when I was first getting started, I sold a painting to a lady who worked as a producer in the film industry. After the sale, I followed up and began inviting her to each of my subsequent art events, including Art Teas. I heard nothing from her for two years, and considered dropping her from my list. Then I remembered how busy I had been when I had worked in film—the crazy hours, different locations—and decided to invite her, one last time, to an art event I was producing at a local wine shop. Not only did she attend the event, but she befriended my new artist, and within a month, purchased a $2,800 painting by that artist!

Occasionally, artists *will not* invite their clients or contacts to one of their gallery's or rep's big events because they want to "*save*" the client for their one-person show the following year. They also do not wish to risk losing their client when that client sees and acquires the work of another artist in the show.

This attitude is not wise from a business standpoint. For group shows that include your artwork, you should invite your entire list of contacts or have your gallery or rep do it for you. Not everyone on your list will attend. By simply inviting people, you will increase your exposure and jog everyone's memory about the fact that you are a successful artist.

Gallery owners and reps count upon a certain amount of cross-pollination—clients purchasing the work of several or all of the gallery artists. Most galleries, therefore, will not separate out names obtained from one artist's mailing list and then treat it differently from the others. For big receptions (usually held once a month), the gallery will invite each and every person who has ever signed the guest book, and current and past clients, in addition to new contacts, without considering which artist they are featuring that particular week or month.

The only exception they might make would be with their targeted, themed events held in a small space like someone's home—an Art Tea event featuring one particular artist. I have also heard of collectors being invited to have dinner and drinks with the artist, a one-on-one event sponsored by the artist's gallery or rep. Again, there is a space issue in a restaurant, so a smaller list of interested parties will be invited, and RSVP's with a finalized guest list will be required.

WORKING WITH A REP

WHAT IS A REP?

An effective art rep is like a film agent; each performs a similar function. Unlike a gallery, art reps usually represent a small group of artists. I represent only seven, including my late father. An art rep's approach and goals differ from a traditional gallery. Like a film agent, an effective rep:

➤ Develops and nurtures an artist's career by introducing her to the right people who can advance her career

➤ Introduces an artist to important opportunities—major commissions, grants, international exhibitions, etc.

➤ Sells artwork to collectors and others whom an artist would not otherwise know

➤ Obtains commissions (if desired) and negotiates contracts related to those commissions

Your rep may also use his contacts to get press coverage. Depending upon the agreement, one's rep may also try to get an artist's work into galleries, museum exhibitions and permanent collections.

Like a movie theatre, an effective gallery:

➤ Advertises and sells artwork, as much and as fast as possible

➤ Obtains commissions (if desired) and negotiates contracts related to those commissions

A rep actively represents fewer artists and usually does not have a fixed retail location; they often work from home. A rep or dealer takes a personal approach to representing an artist.

A gallery, on the other hand, has a fixed retail location and may represent as many as 200 artists. The gallery concentrates on making sales to anyone who walks through the door. If the gallery is representing 200 artists, the owner of that gallery will not have much time to concentrate on you, your career, your issues, and your individual needs.

A rep can be a great asset

One of your greatest assets if you were an aspiring movie star would be your agent. She would introduce you to important people in the film industry—up-and-coming directors and producers—and would be aware of "behind the scene" happenings. Art reps attempt to do the same in the art world to promote their artists.

For example, I represented an artist who wanted to get a meeting with the executive director of a local, prestigious public arts venue. He had already called the venue and been told that he could submit his portfolio to them for consideration, but it would take them at least six weeks to evaluate his work. (In other words, he was told to "go away.")

My approach was different. In order to have a meeting for the artist, I decided to use my contacts. I called the curator of a well-known museum in Northern California. I asked him if he knew the executive director of our local public arts venue. As it turned out, not only did the curator know the director, but they were friends and had once worked together. He gave me the director's direct phone number. I called on a Tuesday, got the director himself on the line, introduced myself (being sure to mention our mutual friend up north), explained why I was calling, and asked if I could meet with him. End result: My artist and I had a 40-minute uninterrupted meeting with the executive director three days later. This meeting led to the artist exhibiting one of his projects at the venue. My artist got his much-desired "foot in the door" opportunity through my contact.

This same artist wanted to gain greater exposure in the media, so I called my friend who is a television producer at our local station. I told her all about my artist and asked if she had any guest slots available. End result—he was interviewed twice on her talk show, each time for a half hour.

A gallery owner probably would not have considered it her job to obtain such opportunities for her artist. They do not have the time to pursue endeavors that do not remunerate them immediately—something that art reps, like agents in the film industry, should do as part of their job.

If I were an artist

➤ I would learn how to market my work.

➤ I would set up a merchant account for my art business in order to accept checks and credit cards.

➤ I would host an open studio once a year.

➤ I would learn how to sell my art.

➤ I would create a web presence.

➤ I would enter competitions.

Once I felt that I was "mid-career," I might consider expanding my contacts and visibility nationally by doing one or both of the following:

➤ Get a rep or dealer to represent me who had good contacts and really liked my work

➤ Get into some good galleries—one in my local region and one or more out of state, but in a major metropolitan area that has an active art market—Santa Fe, New York, Los Angeles, etc. (I would try to find a gallery recommended to me by other artists, a gallery that had been in business for at least three years, where the people working the floor were not snooty and really knew how to do floor sales.) I would connect with these galleries every two weeks to check on sales, to exchange artwork if necessary, and to verify that they were still in business.

Why call a gallery every two weeks?

Galleries, like many small businesses, come and go. Even galleries that have been in business a long time can close suddenly. I've heard many stories about this over the years and am still amazed that the artists are often the last to hear that their gallery has closed. If you are represented by an out-of-state gallery, have a friend stop in while on vacation, or ask a fellow artist who lives in the area to visit once a month so you can verify that your work is still on display.

Changing representation

At some point, you may wish to sever your ties with your rep or gallery. Your contract will have information that will give you guidelines to follow as you end the relationship. If for some reason your contract does not cover this information, the professional procedure would be to write a formal letter to the party thanking him for his representation of you. Attached to this letter would be a current consignment list of your artwork on their website, on display or in storage. This letter would state a timeline for concluding your business with them. In the letter, you would ask to make an appointment to pick up your work and any marketing materials—slides, portfolios, photographs—which you provided to them. It is not in your best interest to get angry and tell them off; you may need that gallery or rep again at some point in the future. In addition, the art world, like the film industry, is a small place; word travels fast. You do not want to be known as someone who is especially difficult.

If you wish to keep the relationship, but want to rotate out your inventory because it has not sold within a given period of time, then notify your gallery or rep via phone as well as in writing. Make arrangements with them to pick up the work and exchange it with other pieces that they might be able to sell for you. Remember: They want to be successful selling your work and representing you. It is in their best interest.

ETHICAL PRACTICE

Gallery owners, art reps and even dealers are often happy, or at least accepting, of having their artists represented by galleries in other states because it increases the artist's name recognition nationally. I have signed artists who are represented in other states as well as within California. If the artist has her work on display permanently in a local (Pasadena) gallery, however, I will not sign her. Most gallery owners I've met not only feel the same, they will not represent any artist who was represented in the past by a competitive gallery located in their town. Many reasons exist for this, the primary one being conflict of interest. If I build up an artist's reputation so he becomes a known commodity, the last thing I want is for someone else to benefit from all of my hard work. I respect other galleries and their hard work as well and would not want to be known for "stealing" artists with whom they have been working.

If a second gallery or rep wishes to represent you, review your contract and consignment list with your existing representative. Make sure there are no restrictions in developing a new relationship.

Chapter 8

Hosting a Reception

Goals for the big day
A successful reception
A successful artist
One gallery reception
Approaching a rep

You miss 100% of the shots you never take. Wayne Gretsky



GOALS FOR THE BIG DAY

Most artists do not understand the value of their opening event. An opening reception is an artist's biggest and best sales opportunity of the entire year. Many artists turn their reception into a party or a family reunion and ruin the possibilities of sales. An opening reception is meant to expose new and existing clients to new work and to *sell* that work.

Reception goals

To keep focused, create goals for yourself before a reception:

➤ Make sales.

➤ Cultivate clients and new contacts.

➤ Obtain commissions (if desired).

➤ Promote yourself and your website.

➤ Find another good location (obtain referrals) for selling the work.

➤ Make the owner glad that the event was held at her place of business.

Party time

➤ Host a party for your friends and family after the event or the next day.

➤ Come to the reception unencumbered, ready to schmooze and sell your art.

➤ Hire a salesperson or solicit the help of a friend or family member to help you close sales.

➤ Arrive early for your reception. Serious collectors want first pick. Be there to greet them. They will be impressed.

A SUCCESSFUL RECEPTION

One of the most successful art receptions I ever attended was for an artist who was showing her work at a nationally-known, high-end restaurant. The reception was held on a Monday night. The artist solicited the help of her friends, who each took turns sitting at a small table that was stationed next to the entrance, one that you would have to pass as you entered the space. Her friends would smile, greet each guest, and ask them to sign the guest book. Next to the guest book was a list of all of the pieces in the exhibit, with title, size, and price, not unlike a gallery. A box with index cards of the paintings (her special filing system) was also on the table, along with a credit card imprinter (slider) and the artist's note cards and brochures.

The person greeting everyone would smile and thank each guest for attending and point to the bar not 10 paces away. After guests picked up their wine, they would proceed through the space into the restaurant to see the artist, who was happily greeting everyone and discussing each of her pieces.

Several days after the reception, I learned that the artist was married and had a nine-year-old daughter who was home that night with her father. They had come by earlier (before the reception) to see everything, and then left the event so "Mom could work."

This particular artist is known in the community and has a good following. Her "affordable" prices range from $375-2,300. She produces a major exhibit of her work once a year at the restaurant and also exhibits her work regularly at large outdoor shows.

A SUCCESSFUL ARTIST

Your opening reception is your single best opportunity to sell your work, when all of your collectors are there in the room with you. The vast majority of sales will happen in the few hours leading up to the opening and during the opening. Don't blow it by turning it into a private party.

The artist mentioned in the previous story sold 12 paintings in two hours. She sold three more after the reception. She was successful because:

➤ She treated her opening as a special event, arranging necessary help.

➤ She informed her family that she would be at work, selling.

➤ She framed her work professionally.

➤ She never allowed herself to be dominated by any one person during the reception. She greeted each guest. Over the course of the evening, she spoke to each and every person in attendance.

In addition:

➤ There was forethought and planning given to the hanging of the art. Each piece was hung at a comfortable distance from the next—uncrowded.

➤ The tables had been moved and chairs strategically placed so that her guests could sit down to have a drink or conversation and at the same time easily view each piece.

ONE GALLERY RECEPTION

A few months ago, I attended the grand reopening of a major gallery in town. The gallery obtained great advance press for their event and had also spent a small fortune on show materials. The lady at the front reception area, who was in charge of sales, was also in charge that night of her two children—handsome boys who each looked to be about four years old. Every time this lady tried to move left or right, one of her sons would bite her, hard, on the arm. These lovely children actually drew blood. After this happened a few times, the lady was in tears. She seemed not to know what to do. Needless to say, her children wanted her undivided attention, and yet she was divided, until the boys won. She spent the next hour trying to discipline her children (and protect herself) and was not able to properly handle the business of the gallery opening—to meet and greet guests and to make sales to collectors.

Despite hundreds of people at the reception, very few sales occurred. I went back to the same gallery a week later and saw that no additional sales had been made.

APPROACHING A REP

Do not dominate the person making sales for the artist.

One of my pet peeves is when an artist whom I've not met previously approaches me at a sales event to talk about his work. Sometimes he even comes armed with a portfolio.

Gallery owners, reps and dealers usually have only about two hours during a reception to sell. If there are 20 pieces of art in the exhibition, 10 pieces will need to be sold in the first hour, 10 in the second hour. One sale will need to be completed every six minutes to sell the entire show!

The last thing any salesperson wants to do at that reception is to spend time speaking with an unknown artist about his work. Ask yourself: How would you feel if your dealer spent 15 minutes at your reception speaking with some other artist about her work?

Thoughtful follow-up

Be sensitive to the situation at hand. Introduce yourself, get a business card, and then move on. Follow up later to let them know you enjoyed the show and to make an appointment. Do not call them the next day; they will be following up on their show, thanking their artist, thanking their new clients and making arrangements for the pickup and drop-off of artwork.

Chapter 9
Selling the Art

Asking questions
The money objection
Rotating an art collection
Caring for art
Develop your own sales style
The "Red Dot Syndrome"
"The Sacred Sales Spot"

Every sale is a good sale, because sales inspire sales. Margaret Danielak

ASKING QUESTIONS

Get the client to talk about your art.

The job of any salesperson selling art is to overcome a mind-set people have when they are exposed to original art. Some reasons for not purchasing I've heard from prospective clients include:

➤ I'm broke right now.

➤ I only buy art in traditional galleries.

➤ My walls are filled; I have no more space.

➤ The only painting I really like is the one you just sold!

➤ I'll think about it.

Your job is to help prospective clients understand that original art is for everyone.

➤ Encourage people to tell you what they like.

➤ Engage clients in conversation.

➤ Get people to talk about where they would put the piece within their home or office.

Ways to connect to clients

The Fondle Factor
Put the artwork into the client's hands. Our first instinct, after looking at something we like, is to touch it. Miniatures and smaller works are easy to sell this way, simply by letting the client touch the work and hold it in his hands. People are not used to being able to "fondle" art, as they do clothes, for example. Ask yourself: Is the client really going to damage the work? If not, let her touch!

Discern the client's taste
Ask questions about what art the client owns or is drawn to. Some people like variety and do not collect just one style. This could be a great customer, one who is not boxed in. Don't be surprised if her face lights up when she starts describing her home and art. Try to picture her descriptions, as well as where the art might be placed in her home. She will be quite pleased you are listening to her.

The client's reaction

If the client does not like your work, he will probably tell you verbally or through his body language. Remember, it is merely a personal preference, not a personal rejection. Back off if he tells you he simply doesn't like it. You are not here to convince anyone of anything. Art is highly subjective, and not everyone will like every work you create.

Keep track of info

Without being too pushy, obtain your potential client's contact information so you can follow up later. Invite her to your next show or put her on your mailing list.

Make sure client is viewing the work

Sit or stand almost in front of your work, facing the client if you are sitting down. (This works especially well in a restaurant setting.) You have seen your own work, so you don't need to see it again. People facing you as they speak will view the work over your shoulder.

Emphasize the sense of discovery

Everyone loves to discover something or someone new. For collectors who only purchase art from "traditional galleries," let them "discover" your work that is unavailable elsewhere. An experienced art buyer might trust her instincts and buy what she loves, regardless of where she purchases the work.

THE MONEY OBJECTION

The most common statement I've heard from prospective clients is, "I can't afford it right now." I've even heard my clients who live in multi-million-dollar homes say to me, "Do I have to rob a bank here?" Robert Regis Dvořák, author of *Selling Art 101*, has a long, lovely list of things you can do to overcome client objections. Some phrases I've developed include:

➤ "I'd be happy to bring this piece to your home or office at no obligation. Then you can see exactly what it will look like in your personal setting." (Nine times out of 10, you will make the sale when they see how good the work looks on their walls.)

➤ "What if I paid the sales tax?"

➤ "I accept both checks and credit cards."

➤ "I'd be happy to offer you 10% off this piece since you bought my other work (or are a member of my volunteer organization, etc.)"

➤ "Would you like to come to my (the artist's) studio for a private tour and to see my other work?"

ROTATING AN ART COLLECTION

Several of my clients have purchased so much artwork over the years that their walls and other display areas are full. As an artist, you could recommend to your clients that they rotate their art collection to bring new energies to their home or office, or perhaps to correspond with the changing seasons.

As the daughter of an artist, with a collection of my late father's paintings and an ever-increasing collection of artwork purchased from the artists I represent, I've learned to rotate my art display every three months. For example, in the summer we display paintings of California and New Mexico that feature cool water elements. In the fall, I display my father's paintings of aspens turning gold. I also change the tablecloth and other accents around the house to fall colors.

Like many people, we entertain often. Our friends and my clients are always delighted when they visit our home because the wall display is never quite the same. We have been asked if we purchased new furniture, but actually we have only changed the artwork. The house seems to have a fresh, new look simply because we rotated our art collection—took some pieces out and introduced some new work.

By rotating one's art collection, one is able to thoroughly dust the work and check the wall behind the piece to see if either natural or artificial lights are causing the wall to discolor, perhaps also affecting the artwork. You could also see if any moisture has built up behind the piece, which could cause great damage to the art over time.

CARING FOR ARTWORK

Increasingly, I'm noticing galleries and reps creating newsletters and other information for their current and prospective clients about caring for art. Such information is useful to your clients and sends the message to them that you care as much about their purchase or investment as they do. Some pointers you could give them are:

➤ When cleaning framed art, do not put sprays or cleansers directly onto the work. Place a very small amount of glass cleaner on a clean cloth and let it soak in a bit. Then gently dust the artwork from top to bottom, being careful not to force moisture into the crack separating the glass and the frame. Cleaning people will sometimes spray glass-covered art directly and then dust it like a table. This should be avoided, as the fluid will seep into the cracks.

➤ When displaying art, keep in mind how heavy it is. When hanging art, use weight-rated hooks, like the kind found in most hardware stores. If you are displaying sculpture, make sure the table or podium is sturdy enough for the piece. Keep the work in place on its stand—with putty or wire—in the event of an earthquake or other accidental occurrence.

Storing art

➤ Wrap each piece in clear, clean plastic, and then put extra bubble wrap or cardboard on each corner.

➤ "File" each piece in boxes.

➤ Store them in a dry closet or place each piece carefully in its hanging orientation—the direction it would hang on a wall—and store it with cardboard dividers on a carpet-lined or padded floor.

➤ Use slim boxes to "file" the more delicate pieces.

➤ For fragile pottery and sculpture, wrap in clear plastic, put bubble wrap around it, and store each piece in a sturdy box.

➤ Create a label for the container so you can locate it easily.

➤ Consider wrapping the artwork in padded paper, like the kind currently used by furniture movers. Padded paper is especially effective in protecting glassed pieces, ensuring that the frame around your art won't get nicked or scratched. It also provides a soft cushion upon which the work rests, so you can store the work in a closet that has hardwood floors.

It takes skill and perseverance to sell art. You may ruffle some feathers and turn some people off as you attempt to make sales. Over time and with practice, you will find a sales style that is effective and welcoming without being too pushy. If nothing else, you must:

➤ Make it clear that the art exhibited is for sale and easy to acquire.

➤ Inspire clients to speak about their home and their tastes, and start conversing with them about the work.

➤ Become a "nice nudge" when following up with these clients.

Multiple sales

Recently, I produced a successful one-man exhibit for a well-known local figurative painter. Two hours before the reception formally began, I sold three paintings to two women whom I had never met before, who came to the exhibition in advance of the opening. During the reception, I sold four more to two other new clients, and after the reception, with follow up, three more pieces were sold.

During the reception, three new collectors bought not just one painting, but two. I also made two unexpected sales outside of the formal exhibit several days after the reception, again because I followed up on some requests that clients made.

"Susan," one of the new collectors who acquired two pieces, admired a small landscape that was no longer available. The landscape was part of a larger series of similar-looking works created by the artist several years ago. At another client's request, I made special arrangements one morning to show the series of small works produced by the artist. "Susan" saw me bringing out this series and acquired one of the landscapes immediately (her third acquisition). The other new collectors came over, saw that I had just made a sale from the series, and immediately acquired one of the artist's smaller works.

DEVELOP YOUR OWN SALES STYLE

Sales breed sales!

THE "RED DOT SYNDROME"

Mark Wood, owner of the Fine Artists Factory in Pasadena, California, has a wonderful expression—the "Red Dot Syndrome." When people see the red sales dot, they will often say, "Oh, I loved that piece! I would have bought that piece if it were not already sold!" Certainly, this is an easy thing for anyone to say. Two possible responses are:

➤ "Oh, you love this piece. Great! I'd be happy to show you other similar works. They're not even framed yet. Would you like to see them?" Then get up and find that work. Start moving toward the room where you have the pieces stored. You are making an extra effort for your potential client. He will appreciate your extra effort and may just buy one of the similar pieces.

➤ "You love this piece? You know, I love commissions! Would you like to discuss a commission based upon this painting? I can create one for you in any size you like."

A sacred sales spot is a "spot" within an exhibition area from where you consistently make sales of your work. For example, at home, I have sold many paintings from my sacred sales spot in our dining room. The "sacred" wall faces to the north and is cut off in the middle by a large window facing the mountains. There is only one light in the middle of the room, under a shell fixture hanging flush to the ceiling. Each and every time I hang a painting on either side of this window and have people over for an art event, someone will buy the pieces that hang on that wall.

"THE SACRED SALES SPOT"

It seems to be different for each place we exhibit; there is no set rule. You just have to find the sacred spot by experimenting.

My father's former gallery on Canyon Road in Santa Fe used to feature his watercolors in a small spot in a corner. Sometimes the gallery would even place a plant in front of his work, partially obscuring it. My mother used to object to this until she found out it didn't matter, his watercolor hanging in that unusual spot would sell shortly after being hung.

One of my artists, when displaying his work at one of our spaces in Pasadena, will sell the painting from the small wall located to the immediate left of the entrance. It doesn't matter if the work is framed or unframed, golden or red: He will sell whatever is hung in that spot. The wall in question is rather small, cut off on the right by a door and on the left by an adjacent wall. The light above is three feet from the wall, closer than the lights hanging elsewhere in the space.

Each of my other artists has a similar sacred sales spot at the places where we exhibit and sell their work. Try to observe this phenomenon when you have the fortune to sell continuously from a space.

TRAITS OF A SACRED SALES SPOT

➤ Sacred sales spots are similar in their orientation to the front entrance of the space. Each sacred sales spot faces the street and is located so that the client has to turn around completely (360 degrees) from where he first entered the space.

➤ The spot is not obvious but does showcase the artwork, setting it off perfectly, like a great frame.

➤ People have to walk a little bit away from the entrance and make a small effort in order to find the sacred sales spot. Clearly, a sense of discovery is vital in creating the sacred sales spot.

Some questions you might ask yourself as you hang your work:

➤ Will the viewer gain greater intimacy by my placing the work here?

➤ Is the framing the best for this piece?

➤ Is the lighting at its best?

Lighting

Much research has been done into both the behavioral psychology and biological outcome associated with our exposure to different forms of light. The psychology of buying anything, including art, is no doubt greatly affected by our perception of and reaction to the light itself as it illuminates artwork.

Intrigue

Is the subject or color compelling, encouraging the viewer to move close to the piece? If a client is intrigued, she will look at the piece longer. The longer a client looks at the art, the more connection she will have to it—a factor in any sale.

Ease of viewing

Is the art hung at eye level—53-58″ from the floor to the center of the image? Sometimes it is not possible to hang the art in the way in which you would like. Restaurants often have a wall where you are forced to hang the work very low. For example, you may need to hang your artwork according to how it will look when people are seated rather than standing.

Eyesight

Can clients read the sales tags? As people age, their vision diminishes. You inadvertently discriminate against a large segment of your potential buyers by displaying your work with tags that are too small.

RECOMMENDED READING

Power Color: Master Color Concepts for All Media by Caroline Jasper
Selling Art 101: The Art of Creative Selling by Robert Regis Dvorák
Why We Buy: The Science of Shopping by Paco Underhill

Chapter 10

Following up with Contacts

After an event
Interest list
Frequency of exhibitions
Frequent art buyers

Not everything that can be counted counts, and not everything that counts can be counted. Albert Einstein

AFTER AN EVENT

Many artists think that after the art reception, they can cruise—all their work is over. Wrong. One of the most important parts of an exhibition occurs after the opening event. In order to get the biggest bang for your effort, you must follow up and contact people.

➤ Call the people who bought art from you to thank them for their purchase.

➤ Thank everybody, including personnel at the location and press people.

➤ Follow up with calls and notes for those who attended.

➤ Let others who missed the reception know they were missed.

➤ If the event is successful at that location, book it for the following year. Annual events build interest and clients. Returning to the same locale for the same type of event has great advantages.

One way to keep track of prospective clients and sales is to create an "interest list" of each client as well as potential clients who express interest in a particular piece but who did not, for whatever reason, commit to purchase it. Follow up with these clients and keep notes about your conversation, nudging them along slowly but surely.

Your chart might look like this:

INTEREST LIST

SAMPLE INTEREST LIST

Contact Date	Client Name & Phone Number	Art Piece	List Price	Discussed Price	Notes
1/5	J. Johnson Phone:	*My Backyard* Oil 24x48"	$3,200 plus tax	$3,200	***Call back in 10 days.***
1/5	S. Foote Phone:	*His Big Ego*	$1,600	$1,600	*Left word.*
1/5	K. Clark Phone:	*Flowerpots*	$1,200 plus tax	$1,200 plus tax	*Sale via credit card/phone sale. Client to pick up.*
1/6	F. Daniels Phone:	*Goddess*	$3,000	$2,900	*Bring to client's home for consult on Sunday.*
1/16	J. Johnson Phone:	*My Backyard* Oil 24x48"		$3,200 (including sales taxes)	***Bring to home Sat. @10 a.m.***

Be available and stay in touch with your clients. Offer to bring the work to your client's home or office.

Dedicate at least one hour each and every day (or one entire day each week) to calling clients and prospective clients. This is one way you will learn if a client's circumstances have changed. Your clients may have purchased a new home, redecorated their living room, or may feel more flush financially and be interested once again in the pieces they admired weeks or months before. They will probably not call you to tell you about their new circumstances, however. It will be up to you to follow up with them to secure the sale.

A friend admired one of my artist's large paintings and nearly bought it. My friend's son was in his last year of college, however, so he ended up passing on the acquisition because he needed that money for his son's books. A year later, after I heard that his son graduated, I sent him a congratulatory note with the words, "Good job, Dad!" A month later, I contacted my friend again, inquiring into his interest in the painting, which had not yet sold. His email reply: "Where do I send the check?"

Delayed sales

One of the most frustrating aspects of the art business is the phenomenon that I call "delayed sales." These are sales that are going to take place, but for whatever reason, do not happen within the period of time you expect. I've had strong feelings about certain pieces—that they would most definitely sell—and they didn't until a few months later, when the client attended another event prompting them to remember, and then purchase, the piece they admired months (or a year) before. You may want to tear your hair out, but sales do not always happen immediately.

One way to follow up with people is to participate in events regularly and to invite people on your mailing list to those events. This way you can follow up with attendees about other work that they may still be considering but did not act on immediately. For example, my schedule one year looked like this:

FREQUENCY OF EXHIBITIONS

Date	Exhibition	Location
January 19	Icelandic Summerscapes	Restaurant - San Francisco
February 9	Valentine Art Tea	Private Artist Home - S Pasadena
March 29	Ceremonial Songs	Lankershim Art Gallery
April 19	Marketing Fine Art Panel	Cal State Northridge
May 1	Pasadena Scenes	Outdoor Booth Business Assn Mixer
May 18	Spring Art Tea	Danielak Home - Pasadena
June 22	Summer Art Tea	Artist Home
July 27*	Hawaii	Café - North Hollywood
August 16	Call to Arts Expo	Indoor Booth Cal State Fullerton
September 14	Art in the Park	Outdoor Booth - Park La Brea, LA
September 21	Art Tasting	Wine Company - Pasadena
October 5*	Open Studios Tour	Private Artist Home
October 11 & 12	Fall Art Tasting	Wine Company - Pasadena
November 3*	One Woman Show	Restaurant - Pasadena
December 6 & 7*	Holiday Art Tea	Private Home - Glendale

* Partial Participation - Did not book the space.

August has typically been a slow sales month for me. Thus, I use the month of August for follow-up, prep and brainstorming. Ironically, in August of last year, I sold a small abstract painting for $1,800 to a couple who had never before purchased an original piece. They fell in love with the painting in June after attending an Art Tea featuring the artist's work. My follow-up efforts were instrumental in securing that sale. I had six conversations with them, in addition to showing them the original work twice, before they actually purchased the piece.

Referrals

I also receive referrals from galleries and individuals. Perhaps a gallery will contact me because they have "dead air" for a week and need to fill the space even if it doesn't feature their stable of artists. I'll negotiate with that type of venue and give up part of my commission in order to provide a sales incentive to them.

In addition, I have often invited my friends and neighbors over for a drink or coffee and made unexpected sales when they've admired a piece on our walls.

One of my neighbors came over one day to collect some steak bones, which were left over from our dinner the previous night, for her dogs. She saw one of my father's paintings, which to my great delight, she acquired right then and there. I had to remind her about taking home the bones for her dogs!

FREQUENT ART BUYERS

Last year, in honor of one of my clients acquiring her 12th piece from my company, I instituted a Frequent Art Buyer (FAB) program.

How collectors become members is easy. They simply purchase $7,000 worth of art or acquire seven pieces (whichever comes first) from DanielakArt - A Gallery Without Walls. I chose this number in honor of the number of artists I represent.

FAB clients receive the following:

➤ Advance notice of special events

➤ Ten-percent discount on all future purchases from any artist I represent

➤ An invitation to a yearly luncheon

➤ A lovely bottle of wine or other gifts during the holidays

Treat your clients like gold. Think about offering your customers a client incentive, regular discount or special gift. This will make you stand out from the crowd.

Sales Strategies for Mature Artists

Getting noticed

All my life I used to wonder what I would become when I grew up. Then, about seven years ago, I realized I was never going to grow up . . . that growing is an ongoing process. M Scott Peck

GETTING NOTICED

You can approach the age barrier and put it to your advantage.

Unfortunately, most members of the "art world," like other groups in our popular culture, give special attention to young—under 40—artists, even though many of the world's greatest artworks are created by artists who are over 40.

Be proud of your age
Think positively about your wealth of experience. This experience is what sets you apart from younger artists and can become a large part of what makes you and your work more interesting to potential clients.

Make your maturity work for you
When I sent out press packets for a local show featuring my father's acrylics of Pasadena, I mentioned the fact that he started his art career during World War II by sketching girls from memory for lonely soldiers. I also emphasized that he had been painting for 50 years—information that contributed to the show receiving excellent press coverage.

Go out of your way to be friendly
Dianne Boate, the San Francisco-based international designer, photographer and writer, always wears a unique hat of her own design to social events. Every time she does this, people gravitate toward her, commenting on her chapeau, asking her where it came from. They tell her that her hat "makes them happy." Inevitably, the hat becomes the focal point of a conversation wherein she describes her fabulous designs and photographs, which in turn leads to numerous sales of her work.

Create business cards that feature your artwork
I created a DanielakArt - A Gallery Without Walls business card for my father that features one of his lovely watercolors. During an office visit, he happened to hand one of these cards to his doctor. Later that day, the doctor logged onto my website and then emailed me, asking if he could see a few originals. Within the week, the doctor, who has known for years that my father is an artist (but had never seen his work), purchased two large watercolors.

Make it easy for people to reach you
Every brochure, business card, letter, proposal, and article reprint that you give to someone about your work should include your complete contact information.

Expand your contacts—join organizations

People love to buy art from people they know because it becomes part of the story they tell their family and friends about the pieces in their collection. You have a great advantage with affluent, educated people who avoid traditional galleries, who prefer to buy their art directly from artists.

Obtain press coverage whenever possible

A painting from a show I produced several years ago was reproduced in the local newspaper along with my telephone number. My client, who could not attend the event, clipped out the news item since it featured a piece of artwork she liked. She kept the article for 10 months until she had the time to call me and financial resources to purchse it.

If a sale doesn't happen

Sometimes people change their minds or decide to go in a different direction. If they can change their minds once, however, they can always reverse it, so be polite and follow up with them to thank them for giving you some of their time. If you had a show and potential clients were unable to attend, then call, email or write a note saying they were missed, and offer to show them your work at a more convenient time.

Consider every sale a good sale—sales breed sales

Let people know about your success. Speak animatedly about your sales, and others will want to jump on the bandwagon. Treat those who buy a $30 print as being as important as those who have purchased a $3000 original. Soon they will!

Procure a web presence

Even if you only have one page of work on the Internet with your contact information and a couple of samples of your work exhibited, do it! It is very important in this day and age. You won't really look like you are in business and actively selling your work if you don't have a web presence.

When speaking with someone about art, try to discern their taste. Avoid putting down other artists' work. When you put down another's work, you ultimately do harm to yourself.

RECOMMENDED READING

Internet 101 by Constance Smith and Susan F Greaves

Chapter 12
Marketing Attitudes

Adopting art
Shooting yourself in the foot
You are your own best rep

Do, or do not. There is no "try." Yoda of *The Empire Strikes Back*, story by
George Lucas, screenplay by Leigh Brackett and Lawrence Kasdan

ADOPTING ART

My attitude about being the owner of DanielakArt - A Gallery Without Walls was formed by my experience selling my father's artwork. Many of his paintings were pieces I remembered him creating as I was growing up, and they meant something to me. I wanted his paintings to be appreciated and placed prominently in clients' homes and offices—places of honor where my clients' friends and family could see his work.

My philosophy was, and still is, that the art I sell isn't simply a commodity, like so many other things. By selling art in alternative venues, I create an opportunity for some lucky person to "adopt" the art and take care of it—an attitude that informs all of my interactions with both my artists and clients.

Additionally, growing up, I heard many stories about traditional galleries—how and why they don't always work. I also observed that galleries aren't always professionally directed: The owners don't always know how to market and sell the work—they just love art. Galleries come and go frequently, sometimes being in business for a very short time, leaving participating artists disappointed and with no place to exhibit or sell their work.

I strive to gain further exposure for my artists, keeping in mind Geoffrey Gorman's phrase, "Exposure Equals Success."

Every day I see opportunities for artists to sell their artwork. I see businesses that need art on their barren walls, for example, and stores that need sculpture in their windows.

Some reps are hired for an hourly fee or require a monthly stipend, working hard to place their artists' work into galleries and museums. They generally also charge a percentage of sales that they complete in addition to the fee. My goals are different.

In many ways, I am like an old-fashioned gallery owner—albeit an unusual one—without a fixed retail location. My greatest hope is to promote and sell the artwork I represent in places that are appropriate for each artist and her work. I do not believe that one size fits all with respect to venues, including traditional galleries.

➤ I have a set number of artists whom I represent.

➤ My company produces themed events in appropriate settings, featuring my artists' work.

➤ I am compensated only when I effect a sale.

➤ My goal is to sell artwork to owners of those happy homes where the art will be seen and appreciated.

Artists are notorious for undermining their own success. Below is a list of things you can do to avoid shooting yourself in the foot:

➤ Show your best work . . . all the time.

➤ Always be prepared with a business card, brochure and portfolio.

➤ Enter both local and national competitions

➤ Have excellent photos and digital images of all your work

➤ Put competitive prices on your work, including having a range of prices on the pieces you sell

➤ Check in regularly with your rep, gallery or dealer. Find out what is and is not selling.

➤ Continue to keep current regarding the art market

➤ Maintain good records of your sales

➤ Stay in touch with people, especially your collectors

➤ Learn how to market your work

➤ Accept credit cards

➤ Be prepared for exhibits booked far in advance

➤ Respect what others are doing to promote your work

➤ Show up on time for meetings and receptions

➤ Put great titles on your work

➤ Have a clean, neat presentation

➤ Don't push religion or politics in your marketing materials or at your reception.

➤ Don't be jealous of other artists. Find out what makes them successful, and then do that.

➤ Do not turn a reception into a party or family reunion. The people representing you are not paying for you to party with your friends. They are paying for the special opportunity to discuss your work with collectors.

SHOOTING YOURSELF IN THE FOOT

➤ Don't be desperate. Desperation doesn't help art sales. Take on a part-time job if money is that much of an issue for you. Try to make that job art-related—teaching, museum work, etc.—so you can develop clients.

YOU ARE YOUR OWN BEST REP

As an artist, you are challenged every day to keep up a regular schedule of creation and self-promotion. You may think you do not have the time to do it all, but really, you must find the time because the best rep you could ever hire is yourself. You have the ability to create professional-looking marketing materials, and, as this book reveals, the flexibility to create your own "gallery without walls." You can learn how to show and sell your artwork exactly as you want without waiting for a traditional gallery to represent you. Remember, a gallery, rep or dealer can be a great asset, using her contacts to sell your artwork and hopefully advance your career, but no one can replace what you can do. By representing yourself, you become more professional and tackle the issues facing each of us who sell art.

Your greatest asset in promoting and selling your art will always be yourself—your love of art, your ability to create it, and your formidable imagination. In fact, at this moment, you could be showing and selling your art at a bookstore, coffee shop, community center, furniture gallery, hotel, law firm, library, restaurant, theatre, wellness center, wine shop, etc.

Appendix

Resources
Magazines and guides
Index

Appendix

American Society of Interior Designers (ASID)
608 Massachusetts Ave NE, Washington, DC 90002-6006
202.546.3480 202.546.3240 Fax
www.asid.org

Artist Career Training
Aletta de Wal, M.Ed., Director & Artist Advisor
101 First St #103, Los Altos, CA 94022-2750
650.917.1225 650.917.9907 Fax
www.artistcareertraining.com <aletta@artistcareertraining.com>

ArtNetwork
PO Box 1360, Nevada City, CA 95959-1360
530.470.0862 530.470.0256 Fax
www.artmarketing.com <info@artmarketing.com>

Manhattan Arts International
Renee Phillips, Editor-in-Chief
200 East 72 St #26L, New York, NY 10021
212.472.1660
www.ManhtattanArts.com <info@ManhattanArts.com>

Modern Postcard
1675 Faraday Ave, Carlsbad, CA 92008
800.959.8365 760.431.1939 Fax
www.modernpostcard.com

Raphel Marketing
Murray Raphel
118 S Newton Pl, Atlantic City, NJ 08401
609.348.6646 609.347.2455 Fax
www.raphel.com <murray@raphel.com>

Appendix

American Artist Magazine
770 Broadway, New York, NY 10003
800.562.2706
www.myamericanartist.com

Art Business News
6000 Lombardo Center Dr #420, Cleveland, OH 44131
216..328.8926 216.328.9452 Fax
www.artbusinessnews.com

Art Calendar
PO Box 2675, Salisbury, MD 21802
410.749.9625 410.749.9626 Fax
www.artcalendar.com

Art in America
575 Broadway, New York, NY 10012
212.941.2800
www.artinamericamagazine.com

ARTNews
48 W 38th St, New York, NY 10018
212.398.1690 212.819.0394 Fax
www.artnewsonline.com

Collector's Guide
P.O. Box 13566-M, Albuquerque, NM 87192
505.292.7537 505.293.5511 Fax
www.collectorsguide.com

Southwest Art
5444 Westheimer #1440, Houston, TX 77056
713.296.7900 713.850.1314 Fax
www.southwestart.com

The Artist's Magazine
4700 E Galbraith Rd, Cincinnati, OH 45236
513.531.2690 513.891.7153 Fax
www.artistsmagazine.com

Appendix

Bold type = Companies, shows, organizations, authors *Italic type = publications*

MARKETING BOOKS

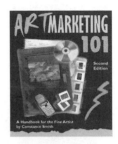

This comprehensive 21-chapter volume covers everything an artist needs to know to market his work successfully. Artists will learn how to avoid pitfalls, as well as identify personal roadblocks that have hindered their success.

Preparing a portfolio * Pricing work * Alternative venues for selling artwork
Taking care of legal matters * Developing a marketing plan
Publicity * Succeeding without a rep * Accounting
Secrets of successful artists

Art Marketing 101: A Handbook for the Fine Artist. Second Edition $24.95 350 pages

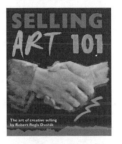

This book teaches artists, art representatives and gallery sales personnel powerful and effective selling methods. It provides easy-to-approach techniques that will save years of frustration. The information in this book, combined with the right attitude, will take sales to new heights.

Closing secrets * Getting referrals * Telephone techniques * Prospecting clients
14 power words * Studio selling * How to use emotions * Finding and keeping clients
Developing rapport with clients * Goal setting * Overcoming objections

Selling Art 101: The Art of Creative Selling $22.95 192 pages

This user-friendly guide explains exhibiting, promoting and selling artwork on-line. It also teaches in detail how one artist made $30,000 selling her art on eBay.

Internet lingo * E-mail communication shortcuts * Doing business via e-mail * Meta tags
Creative research on the web * Acquiring a URL * Designing your art site
Basic promotional techniques for attracting clients to your site * Pay-per-click advertising
Search engines * Tracking visitors * Reference sources

Internet 101: With a Special Guide to Selling Art on eBay $17.95 128 pages

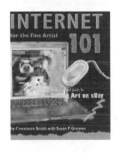

Expose your artwork to potential clients in the art publishing and licensing industry. You will learn how to deal with this vast marketplace and how to increase your income by licensing your art. Contains names, addresses, telephone numbers and web sites of licensing professionals and agents.

Negotiating fees * How to approach various markets * Targeting your presentation * Trade shows
Licensing agents * Protecting your rights

Art Licensing 101: Selling Reproduction Rights for Profit $23.95 224 pages

This book contains 80+ forms that provide artists with a wide selection of charts, sample letters, legal documents and business plans . . . all for photocopying. Organize your office's administrative and planning functions. Reduce routine paperwork and increase time for your art creation.

12-month planning calendar * Sales agreement * Form VA * Model release
Phone-zone sheet * Checklist for a juried show * Slide reference sheet
Bill of sale * Competition record * Customer-client record * Pricing worksheet

Art Office: 80+ Forms, Charts, Legal Documents $16.95 112 pages

ArtNetwork, PO Box 1360, Nevada City, CA 95959-1360
530·470·0862 800·383·0677 530·470·0256 Fax
www.artmarketing.com <info@artmarketing.com>

LOCAL PROMOTION MAILING LISTS

Promote your open studio or exhibition by inviting local art professionals.
The following eight categories will be included in your package:

art publishers
galleries
consultants, reps and dealers
architects
interior designers
museum curators
corporations collecting art
college gallery directors

Some examples:

California	2550 names	$150
Northern California	1250 names	105
Southern California	1300 names	120
San Diego	110 names	50
Los Angeles	700 names	80
San Francisco Bay Area	800 names	85
San Francisco	350 names	55
New York City	1500 names	120
New England	1200 names	100
Boston	210 names	50
Chicago	300 names	50
Illinois	500 names	65
Florida	700 names	80
Georgia	275 names	50
Hawaii	90 names	40
Michigan	350 names	55
Mid-Atlantic	500 names	60
Minnesota	300 names	50
New Jersey	350 names	55
New Mexico	350 names	55
Ohio	250 names	50
Oregon	325 names	50
Seattle	225 names	50
Texas	600 names	75

More geographic areas are listed on-line.
You can also call for a quote on the specific area you need.

ArtNetwork, PO Box 1360, Nevada City, CA 95959-1360
530·470·0862 800·383·0677 530·470·0256 Fax
www.artmarketing.com <info@artmarketing.com>

ART WORLD MAILING LISTS

1.	45,000 Visual Artists	$100 per 1000
2.	900 Art Councils	$80
3.	350 Art Publications	$50
4.	1500 Art Publishers	$115
4A.	725 Greeting Card Publishers	$75
4B.	130 Print Distributors	$50
4C.	325 Greeting Card Sales Reps	$50
4D.	225 Licensing Contacts	$50
4E.	165 Calendar Publishers	$50
5.	350 Book Publishers	$50
6.	550 Corporations Collecting Art	$60
6A.	160 Corporations Collecting Photography	$50
7.	750 Art Stores	$65
8.	1800 Reps, Consultants, Brokers, Dealers	$150
8A.	100 Corporate Art Consultants	$50
9.	2900 College Art Departments	$150
9A.	2900 College Galleries	$150
10.	1600 Libraries	$130
11.	6000 Galleries	$480
11A.	400 Galleries selling Photography	$50
11B.	750 New York City Galleries	$70
11C.	1300 California Galleries	$95
12.	550 Foreign Galleries	$70
12B.	250 Canadian Galleries	$50
13.	2100 Art Organizations and Exhibition Spaces	$140
13A.	450 Art Organization Newsletters	$60
14.	1000 Art Museums	$75
14A.	625 Art Museum Gift Store Buyers	$75
15.	800 Architects	$70
16.	650 Interior Designers	$65
17.	1800 Frame and Poster Galleries	$120

All lists can be rented for onetime use and may not be copied, duplicated or reproduced in any form. Lists have been seeded to detect unauthorized usage. Reorder of same lists within a 12-month period qualifies for 25% discount. Lists cannot be returned or exchanged.

Formats/Coding
All domestic names are provided in zip code sequence on three-up pressure-sensitive—peel-and-stick—labels. We mail to each company/person on our list a minimum of once per year. Our business thrives on responses to our mailings, so we keep them as up-to-date and clean as we possibly can.

Shipping
Please allow one week for processing your order once your payment has been received. Lists are then sent Priority Mail and take an additional 2-4 days. Orders sent without shipping costs will be delayed. **$5 shipping per order.**

Guarantee
Each list is guaranteed 95% deliverable. We will refund 37¢ per piece for undeliverable mail in excess of 5% if returned to us within 90 days of order.

ArtNetwork, PO Box 1360, Nevada City, CA 95959-1360
530·470·0862 800·383·0677 530·470·0256 Fax
www.artmarketing.com <info@artmarketing.com>

LIVING ARTIST DIRECTORIES

In this competitive and fast-paced world, an artist needs to take marketing seriously. Here's a way to do it dynamically and economically! *Living Artists* (formerly titled the *Encyclopedia of Living Artists*) is a direct link to prime customers—including reps, corporate art consultants, gallery owners, architects, art publishers, interior designers, museum curators and more. These artworld professionals use this book to select artwork for various projects. Artwork in the book is reproduced in high-quality full-color, along with artist's name, address and telephone number. Prospective buyers have direct contact with the artist of choice. All fine artists are invited to submit their work. This directory, in its 14th edition, is published biannually, in odd-numbered years. A contest is conducted for the cover position. For a prospectus (August 2006 and 2008 deadlines), e-mail us your street address or leave your name and address on our answering machine.

ArtNetwork, PO Box 1360, Nevada City, CA 95959-1360
530·470·0862 800·383·0677 530·470·0256 Fax
www.artmarketing.com <info@artmarketing.com>

ON-LINE GALLERY

Your web page with ArtNetwork will include five reproductions of your artwork (example at right). Each artwork clicks onto an enlarged rendition, approximately three times the size. Two hundred words of copy (whatever you want to say) are allowed.

Our site averages 625 users a day (and rising each quarter), with the gallery being the second most visited area on our site (the first is our main page).

• We pay for clicks on Google for a variety of art genres: abstract, equine, environmental, nature, etc.

• We publicize our site to art publishers, gallery owners, museum curators, consultants, architects, interior designers and more! We receive over 150,000 hits per month. Your home page on our site will be seen by important members of the art world.

• You will have an address that will take your customers directly to your artwork. Your address will have your name in it: www.artmarketing.com/gallery/johndoe

$240 FOR TWO YEARS FOR FIVE PIECES

To showcase your artwork on-line:

- Email five images in jpg or tiff format. If it is more convenient you can send photo prints. If you send slides, however, there is an extra charge of $25 for converting them into a jpg.
- Include a list of the five images: title, size, medium, retail price, and if prints are available, cost and size of prints.
- Send a check, money order or charge card number (AmExpress/Discover/VISA/MasterCard): $240 for two years of service.
- Include legible copy of no more than 200 words
- Include your email address

ArtNetwork, PO Box 1360, Nevada City, CA 95959-1360
530·470·0862 800·383·0677 530·470·0256 Fax
www.artmarketing.com <info@artmarketing.com>

WWW.ARTMARKETING.COM